PEANUTS™
Family Cookbook

PEANUTS™

Family Cookbook

DELICIOUS DISHES FOR KIDS TO MAKE WITH THEIR FAVORITE GROWN-UPS

weldon**owen**

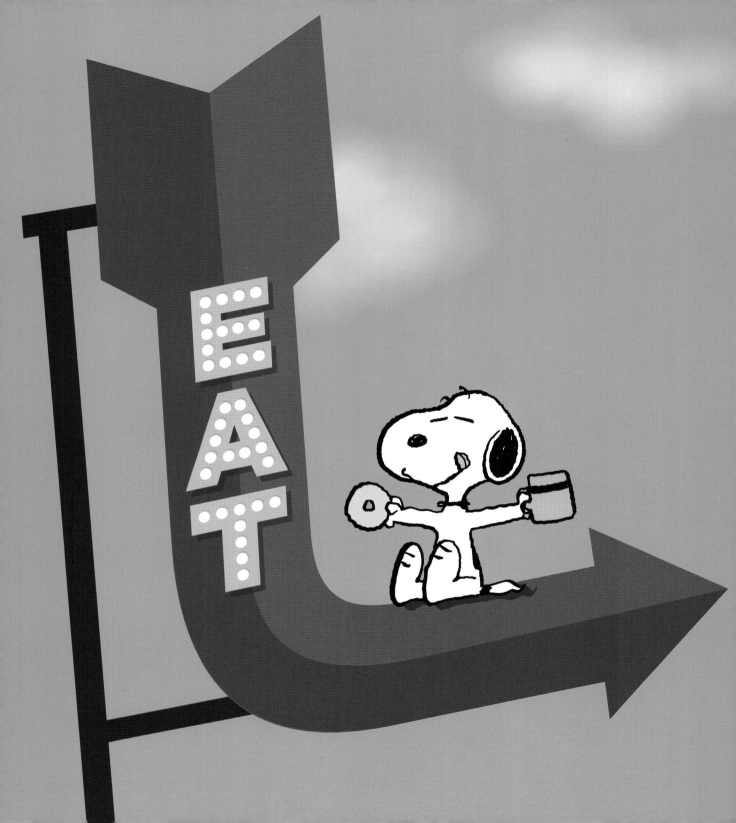

CONTENTS

MMMMMMMMMMMMMMMMMMMMMMMMMMMMMMMMMMMMMM

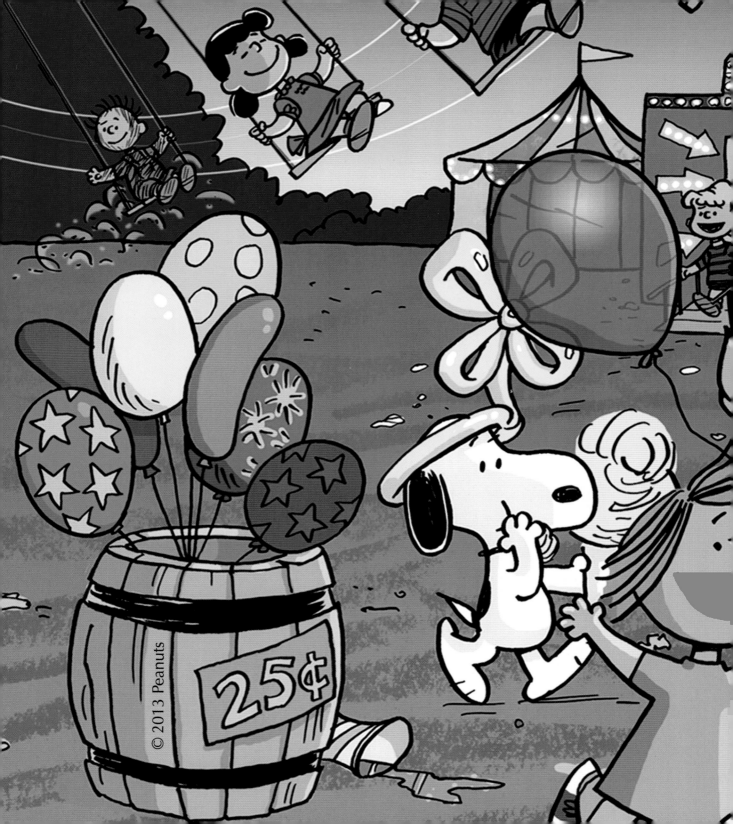

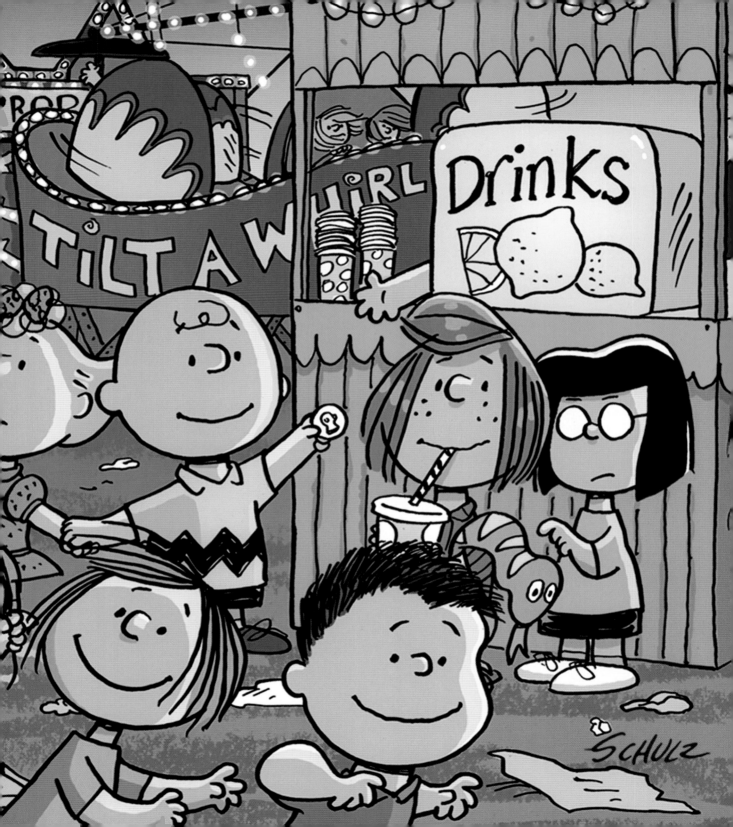

INTRODUCTION

Pizza, doughnuts, pancakes, and ice cream:
Everyone loves these staples of the American diet, and Charles M. Schulz was no exception. He saw the extraordinary comic potential in the various and familiar situations we all encounter relating to food, cooking, nutrition, and mealtime. Mixing these moments with a twist of wit and just the right cast of characters, Schulz developed the perfect recipe for laughter.

Family meals were an important part of Schulz's day, and as a father of five, his children's mealtime antics sometimes influenced the strip. Schulz also remembered how the school lunch period could be a time not only for meaningful conversations, but also for personal turmoil, which found its way into *Peanuts* on several occasions.

For Snoopy, however, suppertime was always the best time of day.

BREAKFAST

WARM PUPPY PANCAKES

Happiness is a serving of these delightful pancakes, which can be topped with fresh fruit or some butter and maple syrup.

INGREDIENTS

2 cups all-purpose flour

2 tablespoons sugar

2 teaspoons baking powder

1½ teaspoons baking soda

½ teaspoon salt

2 large eggs, lightly beaten

1¾ cups whole milk

2 tablespoons unsalted butter, melted and cooled, plus ¼ cup melted for frying and more for serving

Maple syrup and berries, for serving

Makes 3 to 4 servings

1. In a large bowl, sift together the flour, sugar, baking powder, baking soda, and salt. Stir until mixed and make a well in the center. Pour the eggs, milk, and the 2 tablespoons melted butter into the well, then gradually whisk from the center outward, until the ingredients are combined but still a little lumpy; do not overmix the batter, or the pancakes will be heavy.

2. Preheat a nonstick or cast-iron griddle over medium-high heat until a drop of water flicked onto the surface dances and evaporates instantly. Brush the griddle with a little of the ¼ cup melted butter. Slowly ladle a scant ¼ cup of the batter onto the griddle, centering the ladle over the batter so it spreads out into a circle on its own. If necessary, use the bottom of the ladle to nudge the batter into a perfect circle. Continue ladling out the batter to make as many pancakes as you can fit without letting them touch. If they do touch, separate with the edge of a spatula.

3. When the pancakes have begun to bubble in the center and a few of the bubbles have popped and the undersides are golden, about 2 minutes, use the spatula to flip them. Cook until the second side is golden, about 1–2 minutes longer, then transfer to an uncovered platter in a low (200°F) oven to keep warm. Cook the remaining pancakes in the same way, adding butter to the griddle as needed.

4. Transfer the pancakes to individual plates and serve at once with butter, maple syrup, berries, or any of your favorite toppings.

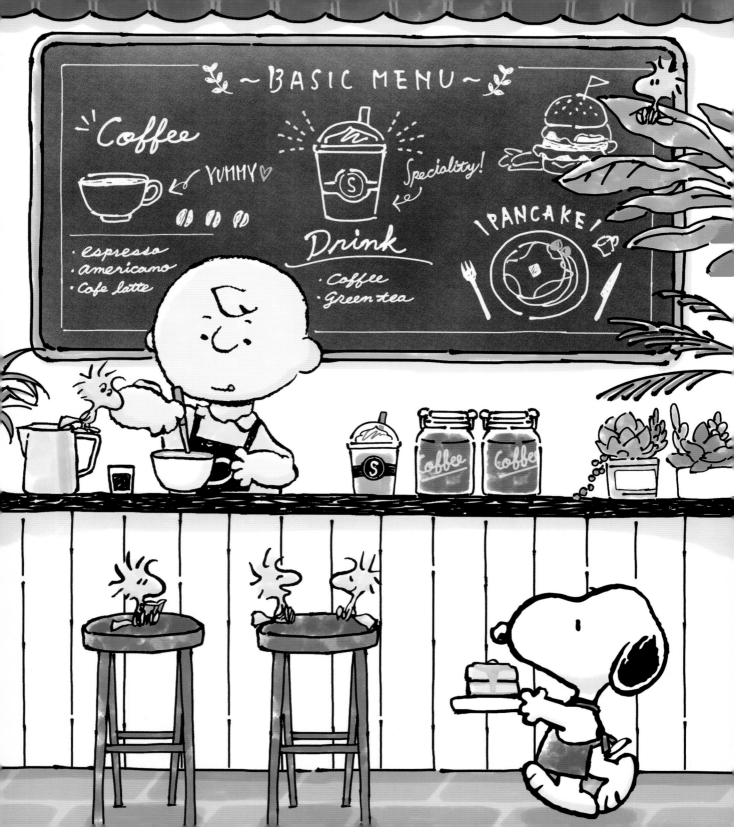

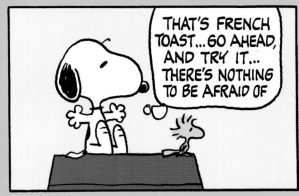

THAT'S FRENCH TOAST...GO AHEAD, AND TRY IT... THERE'S NOTHING TO BE AFRAID OF

THERE MIGHT BE ONE SLIGHT PROBLEM

THE SYRUP MAY STICK TO YOUR FEET...

1-18

FRENCH FOREIGN LEGION TOAST

If you use a lighter bread like challah, slice it the night before and let it sit overnight—a little staleness helps avoid sogginess!

INGREDIENTS

6 slices sturdy French or
 sourdough bread,
 about ¾ inch thick
1½ cups whole milk
4 large eggs
1 tablespoon vanilla extract
¼ teaspoon ground nutmeg
⅛ teaspoon salt
2 tablespoons unsalted butter
Confectioners' sugar, for dusting
Maple syrup, for serving

Makes 3 to 4 servings

1 In a large baking dish, place the bread slices in a single layer.

2 In a large glass measuring pitcher, thoroughly whisk together the milk, eggs, vanilla, nutmeg, and salt. Pour evenly over the bread slices and let stand for 1 minute, then turn the bread slices over. Cover the dish with plastic wrap and let stand for at least 10 minutes and up to 30 minutes.

3 In a large frying pan over medium heat, melt 1 tablespoon of the butter. When the butter has foamed and the foam begins to subside, add as many slices of bread as will fit in the pan without overlapping. When the slices are golden brown on the bottom, about 3 minutes, carefully turn them over using a spatula and cook until golden brown on the second side, about 2 minutes longer if you like custardy French toast, or about 3 minutes longer if you prefer drier French toast.

4 Transfer the slices to an uncovered platter in a low (200°F) oven to keep warm. Melt the remaining 1 tablespoon butter and repeat with the remaining slices.

5 Transfer the French toast to individual plates, dust with confectioners' sugar, and serve at once with maple syrup.

SPIKE'S DES[S]ERT WAFFLES

Nothing powers up a morning like waffles for breakfast! Add blueberries and strawberries to create an oasis of natural sweetness.

INGREDIENTS

2 large eggs

1¾ cups buttermilk

¼ cup canola oil

1 tablespoon sugar

½ teaspoon ground cinnamon

¼ teaspoon baking soda

1½ cups all-purpose flour

2 teaspoons baking powder

⅛ teaspoon salt

Butter, maple syrup, berries, or other favorite topping, for serving

Makes 4 to 5 servings

1 Preheat a waffle iron. In a large bowl, using a sturdy whisk, beat the eggs until evenly mixed. Add the buttermilk, oil, sugar, cinnamon, and baking soda and whisk together until well combined. Add the flour, baking powder, and salt and whisk just until the large lumps disappear. Transfer the batter to a large glass measuring pitcher.

2 When the waffle iron is hot, pour some batter evenly over the center of the grid, easing it toward, but not into, the corners and edges with a wooden spoon or heatproof spatula. Close the iron and cook according to the manufacturer's directions until the exterior of thewaffle is golden brown and almost crusty and the inside is soft, light, and springy, about 4 minutes. (The first waffle may not be perfect. Adjust the amount of batter and cooking time for the remaining waffles if necessary.)

3 Transfer the waffle to an uncovered platter in a low (200°F) oven to keep warm while you cook the remaining waffles in the same way.

4 Divide the waffles among individual plates and serve at once with butter, maple syrup, berries, or any of your favorite toppings.

POOR SWEET (DUTCH) BABY

Whether you're sleepy, under the weather, or just in the mood for something uplifting, try this dazzling, puffy oven pancake topped with fresh raspberries and a liberal dusting of confectioners' sugar.

INGREDIENTS

3 large eggs

⅔ cup whole milk

⅔ cup all-purpose flour

¼ teaspoon salt

2 tablespoons unsalted butter, melted

1 pint fresh raspberries

Confectioners' sugar for dusting

Makes 2 to 4 servings

1 Place a 12-inch ovenproof frying pan in the oven and preheat the oven to 425°F.

2 In a blender, combine the eggs, milk, flour, and salt and blend until smooth. With the motor running, drizzle in 1 tablespoon of the melted butter and blend until incoprorated.

3 Put the remaining 1 tablespoon butter in the hot frying pan. Using a pastry brush, carefully brush the butter all over the pan bottom and sides and pour in the batter. Immediately return the pan to the oven and bake until the Dutch baby is puffed and golden, 15–20 minutes.

4 Remove the pan from the oven and pour the raspberries into the pancake bowl. Sprinkle with the confectioners' sugar. Cut into wedges and serve.

PIG PEN'S SCRAMBLE

Don't worry about keeping these eggs nice and orderly—the better the ingredients are mixed up, the tastier the scramble!

INGREDIENTS

8 large eggs

2 tablespoons whole milk

Salt and freshly ground pepper

1 teaspoon canola oil

¼ pound salami, diced

1½ tablespoons butter

1 cup firmly packed baby arugula

Makes 4 servings

1 In a large bowl, whisk together the eggs, milk, and a pinch each of salt and pepper. Continue whisking until the eggs are nice and frothy.

2 In a nonstick frying pan, warm the oil over medium heat. Add the salami and cook, stirring occasionally, until browned in spots, 3–4 minutes. When the salami is well browned, reduce the heat to medium-low and add the butter. When the butter has melted, add the eggs and let cook until they just begin to set, about 1 minute. Using a heatproof rubber spatula, gently stir the eggs around the pan, lifting and folding, letting any uncooked egg run onto the bottom of the pan. When the eggs are about half cooked, 1–2 minutes more, stir in the arugula. Stir gently, cooking until the eggs have set, about 1 minute more. Transfer the eggs to a serving platter and serve at once.

Panel 1: LOOK WHO WE PLAY IN THE FIRST ROUND... "CRYBABY" BOOBIE AND "BAD CALL" BENNY!

Panel 2: BOOBIE COMPLAINS ABOUT EVERYTHING, AND BENNY CALLS EVERYTHING "OUT"!

Panel 3: I REMEMBER THE LAST TIME I PLAYED AGAINST HIM...

Panel 4: AS SOON AS I OPENED THE CAN OF BALLS, HE CALLED THEM "OUT"!

EGGS "BADCALL" BENNYDICT

There can be no dispute, this eggs benedict will score a lot of points with your breakfast partner.

INGREDIENTS

FOR THE HOLLANDAISE SAUCE:

1 cup unsalted butter, plus more for spreading
2 large egg yolks
1 tablespoon fresh lemon juice
½ teaspoon salt
Freshly ground pepper

2 English muffins, split
4 slices Canadian bacon
4 large eggs
2 tablespoons minced fresh chives

Makes 2 servings

1. To make the hollandaise sauce, in a small saucepan over medium heat, melt the 1 cup butter. Set aside to cool for 5 minutes. In a heatproof bowl, combine the egg yolks, 1½ tablespoons water, and lemon juice. Set the bowl over, but not touching, barely simmering water in a saucepan. Using a balloon whisk, begin whisking as soon as the yolks are over the heat. Whisk constantly until the mixture is light and fluffy, about 4 minutes. Remove the bowl and continue whisking away from the heat to cool slightly, about 1 minute.

2. Slowly drizzle the melted butter into the yolk mixture with one hand while continuing to whisk with the other until all the butter is absorbed into the yolk mixture, then whisk in the salt and a pinch of pepper. Cover the bowl and set aside while you poach the eggs (step 5). The sauce can be kept warm for up to 30 minutes by placing the bowl over hot (but not simmering) water in a saucepan away from the heat.

3. Toast the English muffins in a toaster or toaster oven. Spread the muffins with butter, then place 2 halves, cut sides up, on each plate. Keep warm in a low (200°F) oven.

4. In a dry, nonstick frying pan over medium-high heat, sauté the Canadian bacon just until golden and crisped to taste, 1–3 minutes on each side. Transfer to a baking sheet and keep warm in the oven.

5 To poach the eggs, bring a generous amount of water to a boil in a large sauté pan with high sides and a tight-fitting lid. Add 1 teaspoon of distilled white vinegar or lemon juice. Turn off the heat. Working with 1 egg at a time, break the egg into a saucer and gently slide the egg into the water just below the surface. (Alternatively, crack the eggs into an egg poacher and lower it into the water.) Poach only 2 or 3 eggs at a time. Cover and let stand for 3 minutes for runny yolks or 5 minutes for set yolks. Using a slotted spoon, transfer the eggs to a covered dish, bring the water back to a boil, and repeat.

6 Remove the muffins and bacon from the oven. Place a piece of bacon on top of each toasted muffin half. Using the slotted spoon, transfer a poached egg, first resting the spoon briefly on a paper towel to blot excess water, onto each bacon-topped muffin half. Spoon a generous blanket of hollandaise sauce over each egg, sprinkle with chives, and serve.

WOODSTOCK'S EGGS-IN-A-FRAME

Frame your day—and your breakfast—with a crisp piece of toast. Kids will love to see their morning egg peeking out through the hole in the bread.

INGREDIENTS

4 tablespoons butter, at room temperature, plus more for cooking

4 slices whole-wheat bread, or your favorite sliced bread

4 large eggs

Salt and freshly ground pepper

Makes 4 servings

1 Generously butter both sides of the bread, reserving 1–2 teaspoons of the butter. Using a 3-inch round cutter, cut a circle out of the center of each slice of bread and set aside.

2 In a large nonstick frying pan or griddle over medium heat, add the reserved butter, spreading it throughout the pan as it melts. When the pan is hot and the butter is melted, place 2 slices of bread in a single, even layer in the pan, including the cutout circles.

3 Place a small dab of butter inside the hole in both slices of bread. Then, crack an egg into the hole in each slice of bread and season lightly with salt and pepper. Let the egg cook until it just begins to turn opaque, about 2–3 minutes, occasionally poking the white to let any uncooked egg fall to the bottom. Slide a spatula under each slice of bread and its egg and carefully turn them over together. Continue to cook until the yolk is still runny but the white is cooked through, about 30 seconds more. Turn the cutout circles as well, cooking until nicely browned on both sides.

4 Transfer each egg in a frame to a plate with a toast round alongside it. Serve at once. Repeat with the remaining slices of bread, eggs, and butter.

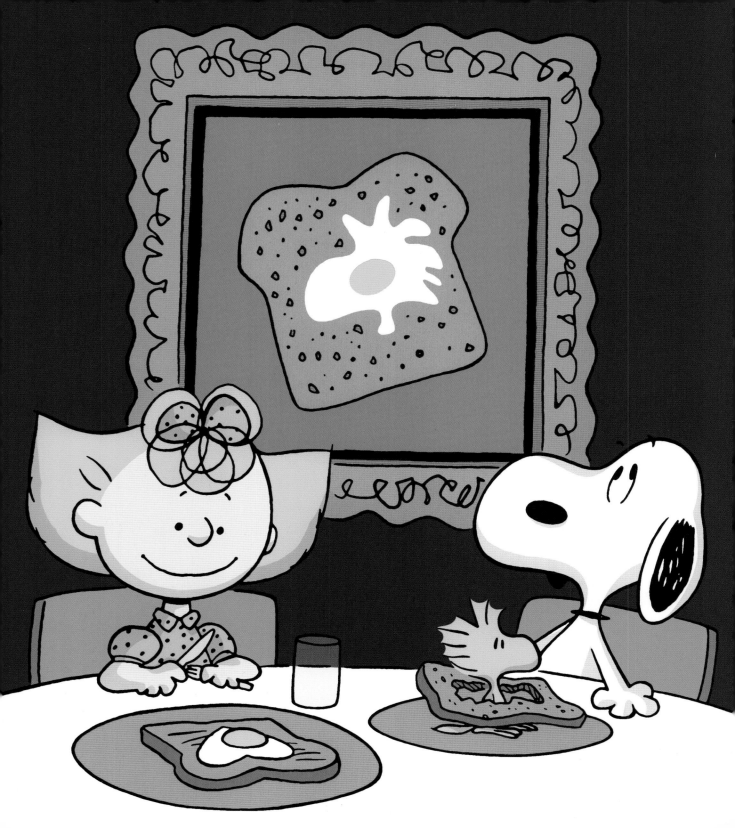

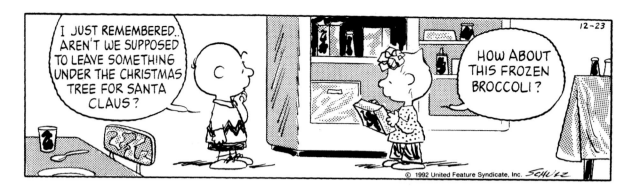

FRIEDA & FARON'S BROCCOLI & CHEDDAR FRITTATA

Don't let the broccoli scare you—it's harmless, especially when paired with cheese in this delicious frittata!

INGREDIENTS

10 large eggs

½ cup sharp Cheddar cheese

1 tablespoon whole milk

1 teaspoon minced fresh marjoram

Salt and freshly ground pepper

1 tablespoon olive oil

1 head of broccoli, cut into small florets

Makes 4 to 6 servings

1 Preheat the oven to 425°F. In a large bowl, whisk together the eggs, Cheddar, milk, marjoram, and a pinch each of salt and pepper.

2 Warm the oil in a 10-inch ovenproof nonstick frying pan over medium heat. When the pan is hot, add the broccoli with a pinch of salt. Cook, stirring, until just tender, 2–3 minutes. Reduce the heat to medium-low and add the egg mixture. Cook, stirring gently, until the eggs begin to set but do not begin to scramble. Continue to cook until the eggs start to set around the edges, 2–3 minutes longer. Transfer the frying pan to the oven and bake until the eggs are set and just firm in the center, about 5 minutes longer.

3 After loosening the sides with a spatula, slide the frittata onto a cutting board. Cut into 4–6 wedges and serve warm or at room temperature.

BANANA NOSE BREAD BITES

Don't throw out those brown bananas—overripe bananas add extra flavor to banana bread, and they are even easier to mash!

INGREDIENTS

6 tablespoons unsalted butter, at room temperature, plus extra for greasing

2 cups all-purpose flour, plus more for dusting

1 cup sugar

2 or 3 very ripe bananas, coarsely mashed (about 1½ cups)

3 large eggs, lightly beaten

½ cup buttermilk

1 teaspoon baking soda

1 teaspoon baking powder

1 teaspoon ground nutmeg

½ teaspoon salt

Makes one 9-by-5-inch loaf

1 Preheat the oven to 350°F. Grease and lightly flour a 9-by-5-inch loaf pan.

2 In the bowl of a stand mixer fitted with the paddle attachment, beat together the butter and sugar on medium speed until creamy, about 1 minute. Add the bananas and eggs and beat until smooth. Add the buttermilk and beat just until combined.

3 In a bowl, stir together the flour, baking soda, baking powder, nutmeg, and salt. Add the dry ingredients to the banana mixture and beat just until combined. The batter should be slightly lumpy. Scrape down the sides of the bowl.

4 Pour the batter into the prepared pan. It should be no more than two-thirds full. Bake until the loaf is dark golden brown and a toothpick inserted into the center comes out clean, 55–60 minutes. Let rest in the pan for 5 minutes, then turn out onto a wire rack and let cool completely. Cut into thick slices to serve.

5 To store, wrap the bread tightly in plastic wrap and store at room temperature overnight or in the refrigerator for up to 5 days.

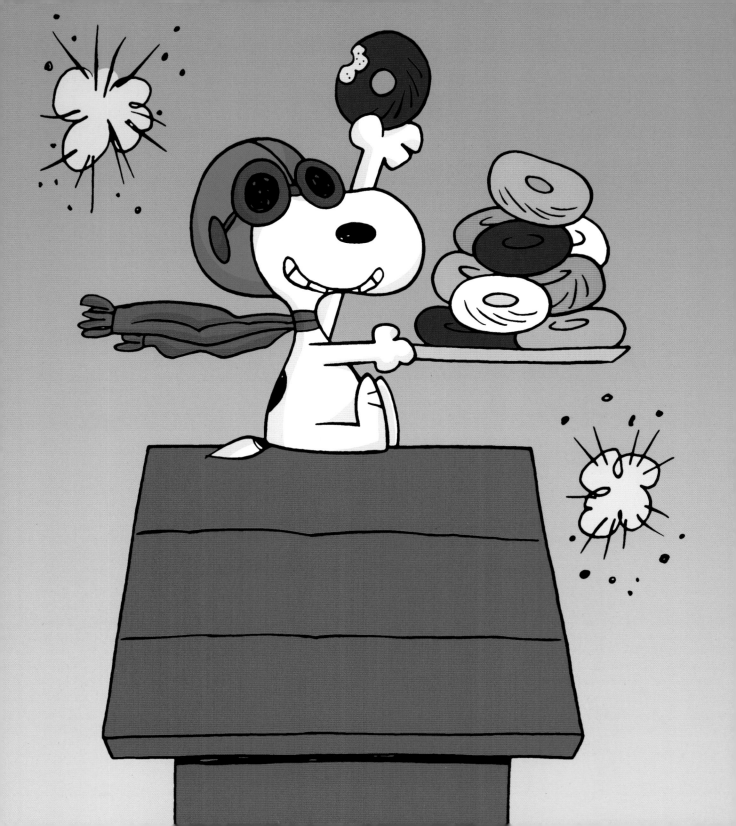

HERE'S THE WORLD WAR I FLYING ACE HIGH OVER ENEMY LINES...

SUDDENLY HE TURNS HIS PLANE AROUND!

SOMETHING IS CALLING HIM BACK...

DOUGHNUTS IN THE RED CROSS TENT!

FLYING ACE DOUGHNUTS

Win over your enemies with a plateful of tasty doughnuts!

INGREDIENTS

1¼ cups all-purpose flour,
 plus more for dusting

1 cup cake flour

1 teaspoon baking powder

½ teaspoon baking soda

½ teaspoon ground nutmeg

½ teaspoon salt

1 large egg

½ cup granulated sugar

½ cup buttermilk

1 tablespoon unsalted butter,
 melted

1 teaspoon vanilla extract

Canola oil, for deep-frying

Confectioners' sugar, for dusting

Makes about 10 doughnuts
and their holes

1 In a large bowl, sift together the flours, baking powder, baking soda, nutmeg, and salt. In another large bowl, using an electric mixer on low speed, or in the bowl of a stand mixer fitted with the paddle attachment, beat the egg and granulated sugar until creamy and pale in color. Add the buttermilk, melted butter, and vanilla and beat until well blended. Add the flour mixture and beat, still on low speed, just until the mixture comes together into a soft dough. Cover and refrigerate the dough until firm, at least 30 minutes and up to 1 hour.

2 On a generously floured work surface, roll out the dough into a circle 10 inches in diameter and ½ inch thick. Using a 3-inch round doughnut cutter, cut out as many doughnuts and holes as possible. Gather up the dough scraps and repeat rolling and cutting.

3 Line a baking sheet with paper towels. Pour oil to a depth of 2 inches into a deep, heavy sauté pan and warm over medium-high heat until it registers 360°F on a deep-frying thermometer.

4 Carefully lower 2–5 doughnuts or holes into the hot oil and deep-fry until dark golden, about 1½ minutes. Using tongs, turn over the doughnuts and cook until dark golden on the second side, about 1 minute longer. Using a slotted spoon, transfer the doughnuts to the paper towel–lined baking sheet to cool. Repeat to fry the remaining doughnuts and holes, allowing the oil to return to 360°F between batches.

5 Arrange the doughnuts and holes on a platter. Using a fine-mesh sieve, dust the doughnuts generously with confectioners' sugar. Serve at once.

INCIDENTALLY, HOW DO YOU GUYS LIKE THE GRAPE JELLY I BROUGHT ALONG?

IT'S A NEW BRAND CALLED "SMIRK"

IF SOMEONE GETS JELLY ON HIS FACE, YOU CAN SAY TO HIM, "WIPE THAT 'SMIRK' OFF YOUR FACE!"

JUST A LITTLE JOKE THERE TO BOOST SAGGING MORALE

PEANUTS BUTTER & JELLY MUFFINS

Make breakfast for the whole gang with these scrumptious morning muffins —just be careful not to get jelly on your face!

INGREDIENTS

6 tablespoons unsalted butter, melted, plus more for greasing

2 cups all-purpose flour

¾ cup sugar

1 tablespoon baking powder

½ teaspoon baking soda

½ teaspoon salt

2 large eggs

1 teaspoon vanilla extract

¼ teaspoon almond extract

1¼ cups sour cream

½ cup jelly or seedless jam of your choice

Makes 12 muffins

1 Preheat the oven to 375°F. Grease a standard 12-cup muffin pan with butter.

2 In a large bowl, stir together the flour, sugar, baking powder, baking soda, and salt.

3 In another large bowl, whisk together the melted butter, eggs, vanilla and almond extracts, and sour cream until smooth. Add the egg mixture to the dry ingredients and stir just until evenly moistened. The batter will be slightly lumpy. Do not overmix.

4 Spoon the batter into each muffin cup, filling it one-third full. Drop a heaping teaspoonful of jelly into the center, then cover with batter until level with the rim of the cup.

5 Bake until golden and springy to the touch, 20–25 minutes. Transfer the pan to a wire rack and let cool for 5 minutes. Unmold the muffins. Serve warm or at room temperature.

GOOD MORNING, CHARLES...

I BROUGHT YOU SOME COLD CEREAL

THANK YOU, MILO...THAT WAS VERY NICE OF YOU

YOU'D BETTER EAT IT FAST, CHARLES...THE MILK IS RUNNING THROUGH MY FINGERS!

SNOOPY'S GRRR...NOLA

Personalize your granola by swapping in your favorite ingredients such as raisins, dried cranberries, sunflower seeds, or chocolate chips (stir in any dried fruits or chocolate after baking).

INGREDIENTS

2 cups old-fashioned rolled oats

½ cup wheat germ

¼ cup coarsely chopped walnuts

¼ cup white sesame seeds

¼ cup shredded sweetened coconut

¼ cup raw hulled green pumpkin seeds

2 tablespoons canola oil

3 tablespoons honey

1 teaspoon ground cinnamon

¼ cup dried currants, or to taste

Makes 4 servings

1 Place the broiler pan on the lowest rack and preheat the broiler.

2 In a large bowl, combine the oats, wheat germ, walnuts, sesame seeds, coconut, and pumpkin seeds. Spread the mixture in an even layer on a large, rimmed baking sheet. Keeping the broiler door ajar, broil, shaking the pan every 30 seconds while keeping the mixture in an even layer, until crisp and golden but not charred, 2–3 minutes. Watch the mixture carefully so it does not burn. Transfer to a large plate to cool.

3 In a small saucepan over low heat, combine the oil, honey, and cinnamon until warm, about 2 minutes. In a large bowl, add half of the honey mixture to the granola and toss thoroughly to combine. Add just enough of the remaining honey mixture so that the granola clumps slightly but is not soupy. Stir in the currants. Store in an airtight container in a cool, dry place for up to 2 weeks.

LUCY'S PRETTY GOOD GOOP

Warm oatmeal is the perfect invention for mad scientists on a cold morning. Top your oats with apricots, banana slices, raisins, or your favorite topping.

INGREDIENTS

2 cups whole milk

1 cup old-fashioned rolled oats

Salt

2 tablespoons unsalted butter

1 tablespoon firmly packed light brown sugar

Makes 2 servings

1 In a small saucepan over high heat, combine the milk, oats, and a pinch of salt. Using a wooden spoon, stir until the mixture begins to simmer. Reduce the heat to medium and continue stirring until the oatmeal is thickened, about 4 minutes.

2 Divide the oatmeal between bowls and top each with 1 tablespoon of the butter. Sprinkle each serving with half of the brown sugar and serve at once.

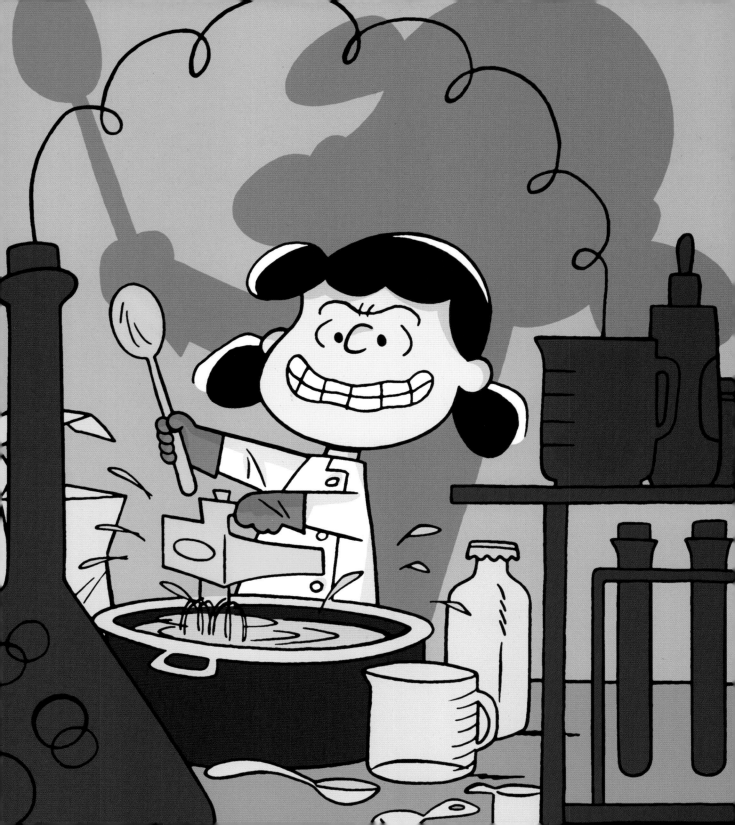

JOE HUNK'S POWER SMOOTHIE

Energize your day with this delicious and nutritious blend of fresh fruit!
If berries are not your thing, swap in bananas, peaches, melon, or any mix
of your favorite fruits.

INGREDIENTS

2 cups strawberries, hulled
1 cup blueberries
1 cup blackberries
1 cup plain yogurt
1 cup ice cubes
Honey

Makes 4 servings

1 Put the strawberries, blueberries, blackberries, yogurt, and ice in a blender and process until smooth. Taste the smoothie for sweetness and add honey as needed.

2 Pour the smoothie into chilled glasses and serve.

SOUPS, SALADS & SNACKS

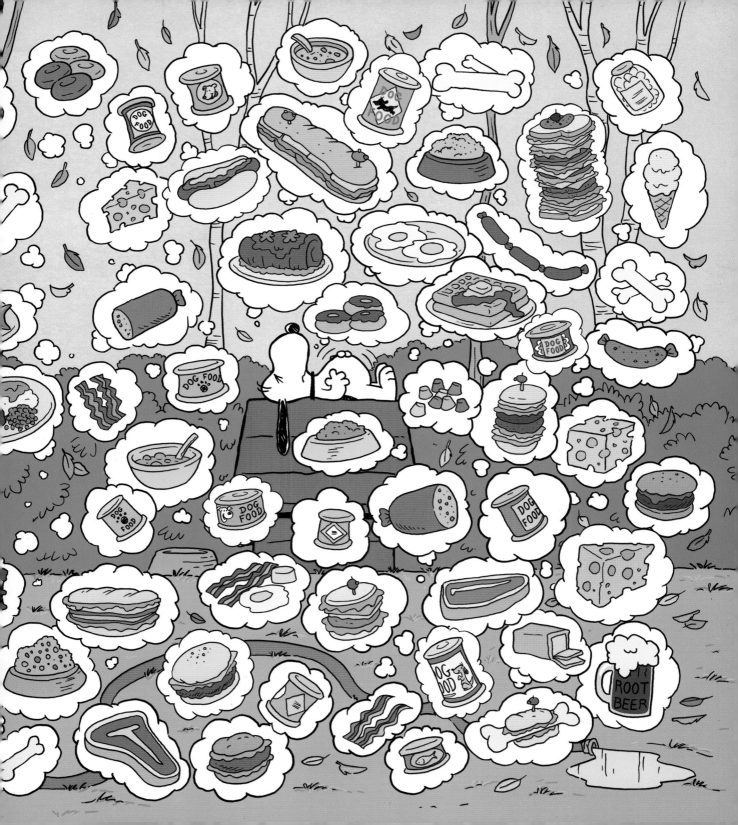

DOG FOOD SOUP

Whether you're sick in bed or just hiding from a cold, blustery day, nothing is better than a hot bowl of Dog Food Soup (perfect for humans, too!).

INGREDIENTS

6 cups low-sodium chicken broth

1 skinless, boneless whole chicken breast (about ½ lb)

1 yellow onion, finely diced

2 carrots, peeled, halved lengthwise, and thinly sliced

2 ribs celery, strings removed, thinly sliced

2 oz dried thin egg noodles

1 tablespoon dried parsley

Salt and freshly ground pepper

Makes 4 servings

1 In a large saucepan over medium heat, bring the broth to a simmer. Add the chicken breast and simmer just until tender and no trace of pink remains, 8–10 minutes. Remove from the heat and let the chicken cool in the liquid. Transfer the chicken to a cutting board and cut into 1-inch cubes. Set aside.

2 Return the broth to a simmer over medium heat and add the onion, carrots, and celery. Simmer until the vegetables are slightly softened, about 10 minutes, skimming away any foam that rises to the surface of the broth.

3 Add the cubed chicken, noodles, parsley, and salt and pepper to taste. Simmer until the noodles are tender, about 3 minutes.

4 Ladle the soup into bowls and serve at once.

Panel 1: I'M FIXING YOUR DINNER RIGHT NOW..

Panel 2: WHILE YOU'RE WAITING, I THOUGHT YOU MIGHT LIKE SOME SOUP..AND WHILE YOU'RE WAITING FOR THE SOUP, I'LL BRING YOU SOME FRENCH BREAD.. 7-23

Panel 3: AND WHILE YOU'RE WAITING FOR THE BREAD, I THOUGHT YOU MIGHT LIKE SOME CARROTS... © 1988 United Feature Syndicate, Inc.

Panel 4: WHAT DO I EAT WHILE I'M WAITING FOR THE CARROTS?

MASKED MARVEL MINESTRONE SOUP

No need to wrestle over what to eat—this classic soup is simply marvelous!

INGREDIENTS

1 tablespoon extra-virgin olive oil

¾ cup yellow onion, chopped

2 cloves garlic, minced

2 stalks kale, well rinsed, stems removed and leaves coarsely chopped

6 cups low-sodium chicken or vegetable broth

1 can (14.5 oz) diced tomatoes

1½ cups frozen vegetable medley, such as green beans, carrots, peas, and corn

1 cup bite-size cauliflower florets

Salt and freshly ground pepper

½ cup small pasta

¾ cup canned cannellini beans

Makes 6 to 8 servings

1 In a soup pot, heat the oil over medium-low heat. Add the onion and cook, stirring often, until tender, 7–10 minutes. While the onions are cooking, bring a separate pot of water to a boil for cooking the pasta. Add the garlic to the pot with the onions and cook, stirring often, for 1 minute longer. Add the kale and cook, stirring often, until it begins to wilt, about 1 minute. Add the broth, the tomatoes and their juices, the frozen vegetables, and the cauliflower. Bring just to a boil over high heat, then reduce the heat to medium-low and simmer until the vegetables are tender but still crisp, about 5 minutes.

2 When the pot of water comes to a boil, add ¼ teaspoon salt, then the pasta. Cook the pasta until al dente, about 7 minutes or as directed on the package. Drain the pasta. Add the drained pasta to the soup. Drain and rinse the beans in a colander, then add to the soup. Simmer until the beans are heated through, about 5 minutes longer. Season with salt and pepper.

3 Ladle the soup into individual bowls. Serve at once. Store any leftover soup in a covered container in the refrigerator for up to 5 days, or freeze for up to 6 months.

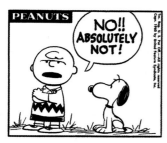 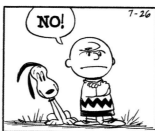 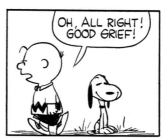

CHARLIE BROWN'S COBBETTES

Corn on the cob is a fun and delicious summertime treat that is made extra special with this garlicky butter!

INGREDIENTS

1 large head garlic

1 teaspoon extra-virgin olive oil

4 tablespoons salted butter, at room temperature

4 ears of corn, husks and silks removed

Makes 12 servings

1 Preheat the oven to 400°F. Cut off the top one-third of the garlic head. Place the garlic, cut side up, on a piece of aluminum foil. Drizzle the oil over the top and seal the head inside the foil. Roast until the cloves are soft, about 25 minutes. Unwrap, let cool slightly, then squeeze the cloves from their papery sheaths into a small bowl. Add the butter and mix with a fork until blended.

2 Cut each ear of corn into 3 equal pieces. Fill a large pot three-fourths full of water and bring to a boil over high heat. Add the corn to the boiling water and cook until the kernels are tender when pierced with a fork, 5–7 minutes. Using tongs, transfer the corn to a platter. Serve hot or at room temperature with the flavored butter alongside.

LUCY'S BIG SALAD

Don't be fussy with this salad—everyone has their own idea of the "right" amount of croutons or Parmesan cheese shavings.

INGREDIENTS

2 cups cubed sourdough or other coarse country bread (1-inch cubes)

3 tablespoons plus ⅓ cup extra-virgin olive oil

1 teaspoon salt

1 teaspoon freshly ground pepper

3 cloves garlic

4 anchovy fillets, plus more for garnish (optional)

1 teaspoon Worcestershire sauce

2 teaspoons red wine vinegar

2 hearts romaine lettuce, separated into leaves

1 large egg

Parmesan cheese shavings, for garnish

Makes 4 servings

1. Preheat the oven to 350°F. Spread the bread cubes on a baking sheet and sprinkle with the 3 tablespoons oil, ½ teaspoon of the salt, and ½ teaspoon of the pepper. Place in the oven and toast, turning once or twice, until golden, about 15 minutes. Remove the croutons from the sheet and let cool. Set aside.

2. In the bottom of a salad bowl, using a fork, crush the garlic cloves with the remaining ½ teaspoon salt to make a paste. Crush 4 anchovy fillets into the paste. Whisk in the Worcestershire sauce, vinegar, and the remaining ½ teaspoon pepper. While whisking, slowly drizzle in the remaining ⅓ cup olive oil to make a thick dressing.

3. Add the lettuce leaves and three-fourths of the croutons to the bowl with the dressing and mix gently but well. Break the egg into the bowl and mix again. Top with the remaining croutons. Scatter the Parmesan shavings over the salad and serve at once, garnished with anchovy fillets, if desired.

Note: This dish contains raw egg. If desired, omit the egg.

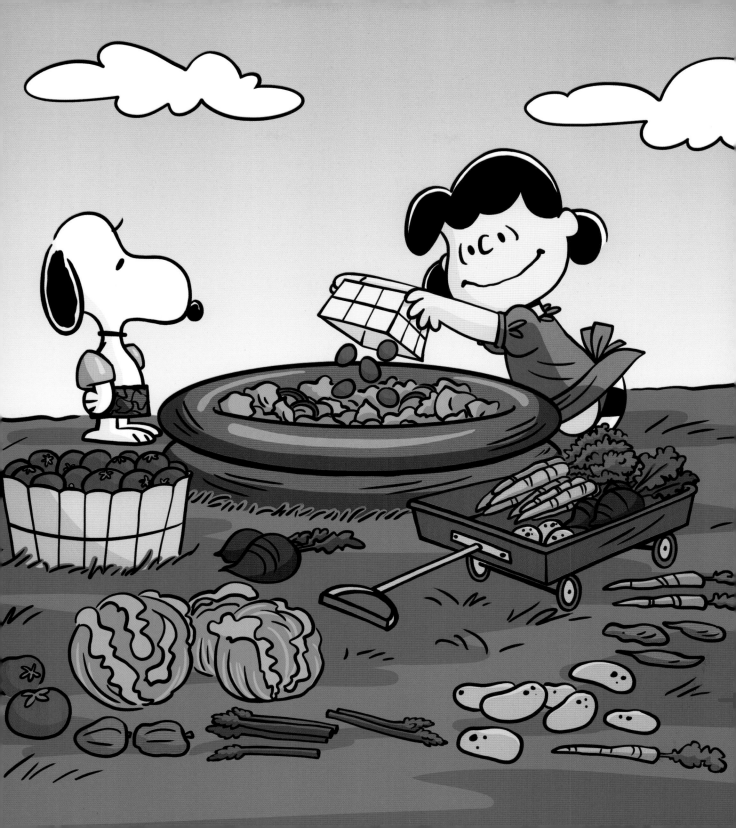

SALLY'S SHRIM PLOOEY

The great thing about this salad is you can make it your own by adding your favorite fixings, such as black olives or pickled asparagus spears, and you can even swap in Thousand Island dressing.

INGREDIENTS

⅔ cup mayonnaise

⅓ cup bottled chili sauce

2 tablespoons sweet pickle relish

Salt and freshly ground pepper

1 head iceberg lettuce, shredded

¼ cucumber, thinly sliced

1 lb cooked tiny shrimp

1 ripe avocado, pitted, peeled, and sliced

2 hard-boiled eggs, quartered

8 red cherry tomatoes

Makes 4 servings

1 In a small bowl, stir together the mayonnaise, chili sauce, relish, and salt and pepper to taste. Cover and refrigerate until needed.

2 In a large serving bowl, combine the lettuce and cucumber and toss to mix. Mound the shrimp in the center and arrange the avocado slices, egg quarters, and tomatoes around the shrimp.

3 Spoon the dressing over the seafood and serve.

SCHROEDER'S FRUIT MEDLEY

Stone fruit like peaches and nectarines can make beautiful music together, especially with a delightful pinch of extra sweetness!

INGREDIENTS

¼ cup sugar

2 tablespoons minced fresh mint

2 teaspoons grated lime zest

2 peaches, pitted and cut into ½-inch-thick slices

2 nectarines, pitted and cut into ½-inch-thick slices

½ cantaloupe or other melon, seeded, peeled, and cut into ½-inch cubes or paper-thin slices

1 cup seedless grapes, halved

Juice of 1 lime

Makes 4 to 6 servings

1 In a small bowl, stir together the sugar, mint, and lime zest.

2 In a large serving bowl, combine the peaches, nectarines, melon, and grapes. Drizzle the fruit with the lime juice and stir gently to coat. Sprinkle with the sugar mixture, turn the fruit once or twice to coat evenly, and serve.

JOE SHLABOTNIK'S BASEBALL SNACK

Hit a home run with this fun snack mix! Raisins, dried cranberries, or dried cherries can be swapped in for the mixed nuts to make a sweet and salty treat.

INGREDIENTS

1 tablespoon unsalted butter

1 teaspoon Worcestershire sauce

½ teaspoon sugar

¼ teaspoon salt

⅛ teaspoon onion powder

⅛ teaspoon garlic powder

1 cup Chex cereal

½ cup mini pretzels

¼ cup mixed nuts

Makes 3 to 4 servings

1 Preheat the oven to 250°F. In a large shallow pan over low heat melt the butter. Stir in the Worcestershire sauce, sugar, salt, onion powder, and garlic powder until well blended. Add the cereal, pretzels, and nuts and toss gently but thoroughly to coat with the seasoned butter. Spread the mixture evenly in a shallow baking dish.

2 Bake, stirring every 10 minutes, until crisp, about 45 minutes. Let cool completely. Pack handfuls of the mix into airtight containers or snack bags.

BEAGLE SCOUTS TRAIL MIX

Always be prepared: Whether exploring a distant forest or their own backyard, Beagle Scouts know to bring along snacks!

INGREDIENTS

Almonds, peanuts, or cashews

Dried cranberries, dried cherries, dried pineapple, or dried mango

Banana chips

Goldfish crackers

Raisins

Mini pretzels

Sunflower seeds, shelled

Chocolate chips

Popcorn

Coconut flakes

Makes 4 to 6 servings

In a large bowl, mix together equal amounts of your favorite ingredients from the ingredients list. Store in an airtight container for up to 3–5 days.

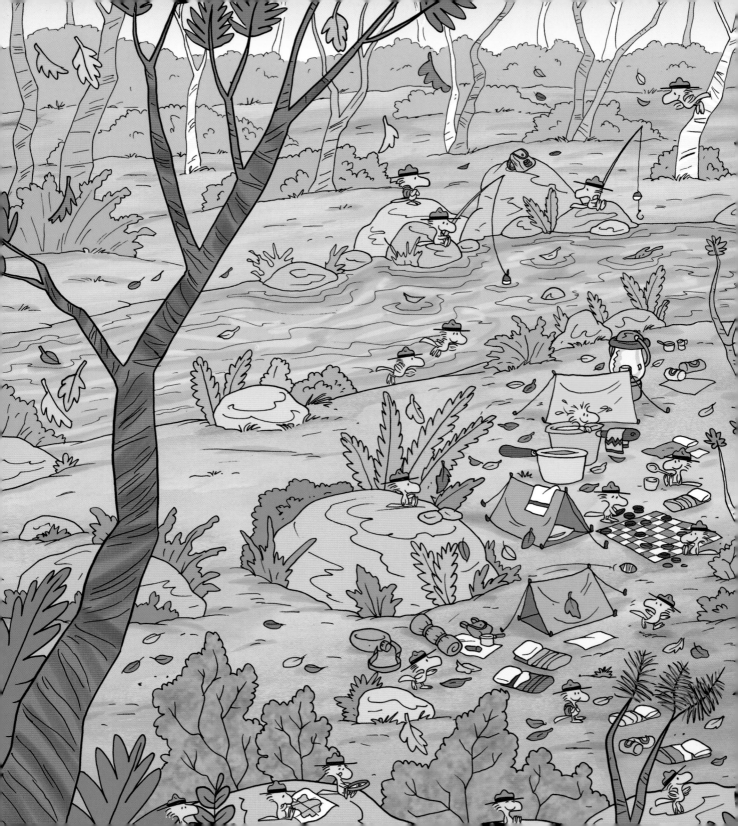

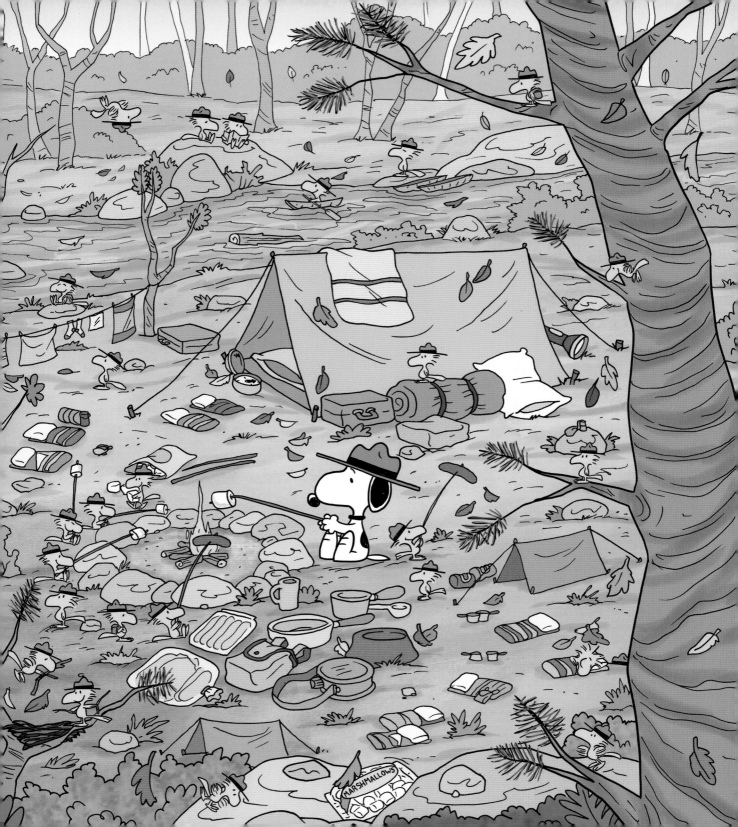

LUCY'S LEMON-AID

On hot summer days, Lucy's Lemon-Aid will come to your rescue with thirst-quenching refreshment that's worth well over five cents!

INGREDIENTS

1½ cups sugar

5½ cups water

10 Meyer lemons

Ice cubes

Makes 5 servings

1 In a small saucepan over medium heat, combine the sugar and 1½ cups of the water and bring to a boil. Reduce the heat to medium-low and simmer until the sugar has completely dissolved, about 10 minutes. Set aside to cool.

2 Slice the lemons in half and discard the seeds. Squeeze the juice from the lemons into a large measuring cup, discarding any remaining seeds; you should have about 1½ cups.

3 Fill a tall pitcher with ice and pour in the lemon juice, 1 cup of the sugar mixture, and top with the remaining 4 cups water. Gently stir and taste for sweetness and add more of the sugar mixture if desired.

4 Fill glasses with ice. Pour in the lemonade and serve.

SODA
POP

made with
REAL
fruit juice

12 FL OZ (355 mL)

SNOOPY'S FRUIT JUICE SODA POP

Make your soda pop with fresh fruit flavors! Lime juice can be swapped for other flavors by puréeing fruit such as raspberries or mango in a blender.

INGREDIENTS

2½ cups sugar

2½ cups water

12 limes

Ice cubes

4 cups seltzer water

Makes 4 to 6 servings

1 In a small saucepan over medium heat, combine the sugar and water and bring to a boil. Reduce the heat to medium-low and simmer until the sugar has completely dissolved, about 10 minutes. Set aside to cool.

2 Slice the limes in half and discard the seeds. Squeeze the juice from the limes into a large measuring cup, discarding any remaining seeds.

3 Fill a pitcher with ice and pour in the lime juice and 2 cups of the sugar mixture. Top with the seltzer water and gently stir. Taste for sweetness and add more of the sugar mixture if needed.

4 Pour the juice into chilled glasses and serve.

SOUPS, SALADS & SNACKS • 61

EASY MEALS

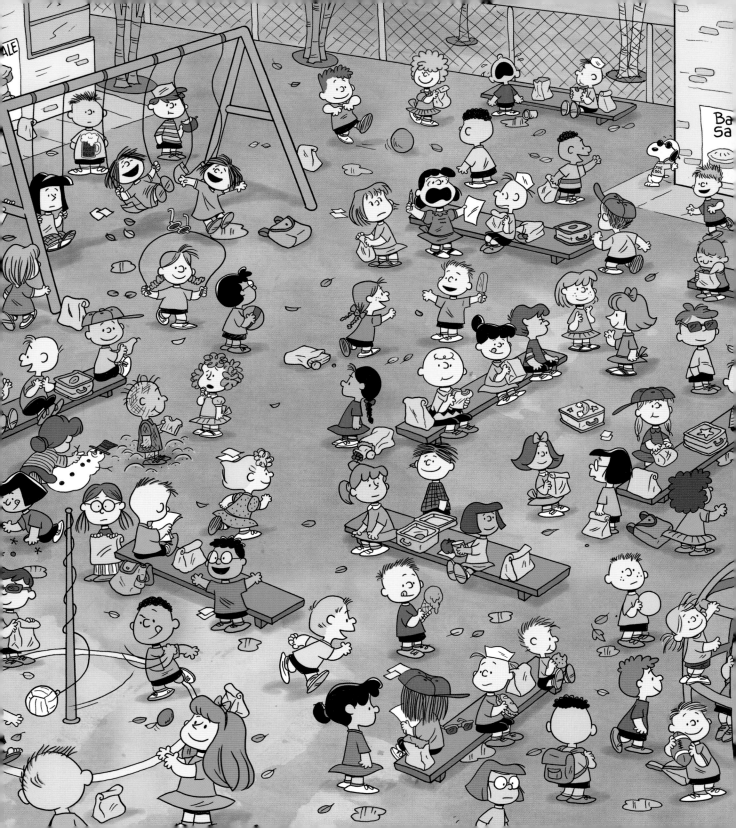

Comic strip:

Panel 1: I LIKE THE WAY YOU CUT YOUR SANDWICH FROM CORNER TO CORNER, MARCIE.. IT SHOWS REAL CLASS..

Panel 2: CUTTING STRAIGHT ACROSS SHOWS LACK OF BREEDING..

Panel 3: OF COURSE, THE BEST WAY IS SIMPLY TO FOLD THE BREAD OVER.. THAT KEEPS ALL THE NOURISHMENT IN..

Panel 4: YOU ARE SANDWICHLY WEIRD, SIR.. / I'M A PURIST, MARCIE..

© 1999 United Feature Syndicate, Inc.

PATTY'S MELT

Make your patty melts distinct by trying different cheeses, such as Cheddar, Swiss, or American.

INGREDIENTS

1 lb ground beef

Salt and freshly ground pepper

4 tablespoons butter

8 slices bread

4 slices cheese

Makes 4 servings

1 Using your hands, form the ground beef into 4 patties, about 3½ inches across and ¾ inch thick, and season with salt and pepper. In a nonstick frying pan over medium-high heat, fry the patties until the undersides are nicely browned, about 3–5 minutes.

2 Using a rubber spatula, carefully turn each patty over and continue to cook until done to your liking, 3–5 minutes on the second side for medium. Transfer the patties from the pan to a plate.

3 Wipe the skillet clean. Spread the butter onto one side of each slice of bread and place 2 slices of bread, butter side down, in the skillet and toast. Top each slice of bread with a cooked burger patty and a slice of cheese, then top with an untoasted slice of bread, placed butter side up. Flip the patty melts when the bottoms are a golden brown, about 2 minutes.

4 Toast the other sides until golden brown, about 2 minutes longer. Transfer the patty melts to an uncovered platter in a low (200°F) oven to keep warm. Repeat with the remaining slices of bread and serve at once.

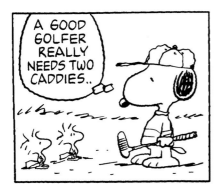
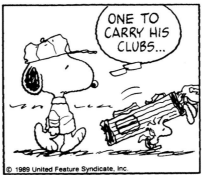
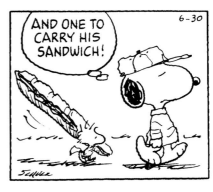

SNOOPY'S GOLF CLUB SANDWICH

The delicious combination of turkey, bacon, tomato, and lettuce makes this world-famous sandwich fit for a world-famous golf pro!

INGREDIENTS

3 slices whole-grain bread

3 slices roasted turkey breast

Salt and freshly ground pepper

2 tablespoons mayonnaise

2 butter lettuce leaves

4 slices small tomato

2 slices cooked bacon

Makes 1 sandwich

1 Lightly toast the bread. Fold the turkey slices on top of 1 bread slice and season with salt and pepper. Spread the 2 remaining bread slices with the mayonnaise, and place 1 slice on top of the turkey, mayonnaise side up. Pile on the lettuce leaves and tomato slices. Arrange the bacon slices on the tomatoes. Top with the remaining bread slice, mayonnaise side down. Press gently.

2 Insert 2 toothpicks deep into the layers, centering them on either side of the sandwich. Using a sharp knife, cut the sandwich in half and serve.

MISS OTHMAR'S FAVORITE CHICKEN PIE

The best chicken pie recipe in the world, for the greatest teacher in the world! There is nothing more comforting than hot savory pie after a long day at school.

INGREDIENTS

1 cup sliced peeled carrots (¼-inch slices)

1 cup shelled fresh peas or thawed frozen peas

1 cup corn kernels (from 2 or 3 ears)

2 tablespoons unsalted butter

4 skinless, boneless chicken thighs, cut into ½-inch pieces

2 tablespoons chopped shallot

¼ cup all-purpose flour

1½ cups chicken broth

½ cup half-and-half

1 teaspoon dried parsley

Salt and freshly ground pepper

1 egg yolk beaten with 1 teaspoon water

One 9-inch frozen pie crust, thawed according to package directions

1 Preheat the oven to 400°F. Bring a saucepan three-fourths full of lightly salted water to a boil. Using a pasta insert or large sieve, immerse the carrot pieces and peas in the water and boil until crisp-tender, 3–5 minutes. Lift out the vegetables, let the water drain off, and transfer to a bowl. Repeat with the corn, boiling for 1 minute. Set aside.

2 In a large frying pan with a lid set over medium-high heat, melt the butter. Add the chicken and cook, uncovered and stirring occasionally, until browned on all sides, about 8 minutes. Add the shallot and cook, stirring, until softened, about 2 minutes.

3 Sprinkle in the flour and stir well. Stir in the broth, half-and-half, and parsley and bring to a simmer. Cover, reduce the heat to low, and simmer for 10 minutes. Stir in the carrots, peas, and corn. Season with salt and pepper. Transfer to a 9-inch pie dish.

4 Brush some of the egg yolk mixture in a 1-inch border around the edge of the pie dough round. Place the round, egg side down, over the filling, and press the dough onto the rim of the dish. Trim off any overhanging dough and brush the surface lightly with the remaining egg yolk mixture. Cut a few slits in the center of the top with the tip of a knife.

5 Place the pie dish on a baking sheet and bake until the crust is golden brown, about 30 minutes. Cool for 10 minutes before serving.

Makes 4 to 6 servings

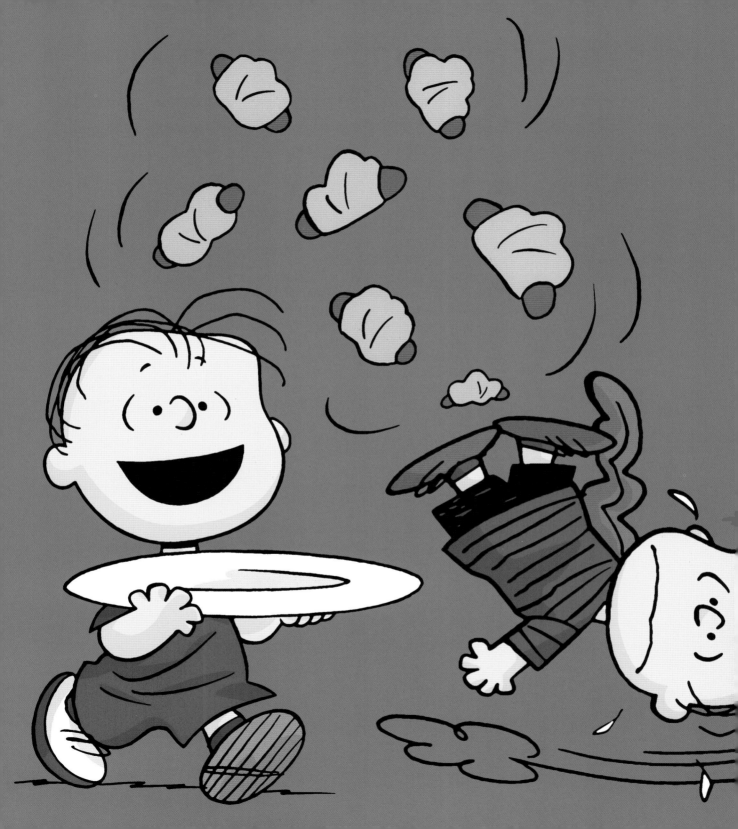

LINUS'S PIGS IN A BLANKET

You can also use store-bought crescent rolls to wrap your piggies in.

INGREDIENTS

2 cups all-purpose flour, plus more for dusting

1 tablespoon baking powder

1 teaspoon sugar

1 teaspoon salt

7 tablespoons cold butter, cut into chunks

¾ cup whole milk

6 tablespoons Cheddar cheese, shredded

6 hot dogs

Makes 6 servings

1 In a bowl, stir together the flour, baking powder, sugar, and salt. Scatter the butter pieces over the flour mixture. Rub the butter into the flour by rubbing your thumb against your fingertips like you are snapping in slow motion. Continue rubbing in the butter until the mixture forms the shape of small pebbles. Slowly add the milk, continuing to use your fingers, until just combined into large chunks of dough.

2 Dump the dough onto a well-floured work surface. Using your hands, press the dough into a mound, kneading gently to incorporate all the flour.

3 Preheat the oven to 450°F. Line a baking sheet with parchment paper. Lightly flour a work surface. Using a rolling pin, roll out the dough into a 10-by-15-inch rectangle about ⅓ inch thick, sprinkling flour on the dough as needed to prevent sticking. Cut the rectangle into six 5-inch squares.

4 Sprinkle each dough square with 1 tablespoon of the cheese. Place a hot dog in the center of a dough square on the diagonal. Lift one uncovered corner of the square up and over the hot dog and press it gently in place. Brush the top of the dough point on the hot dog with water, then lift the opposite corner up and over, nestling it snugly around the hot dog and wrapping it over the first dough layer, pressing gently to help it adhere. Repeat with the remaining hot dogs and dough squares. Place each wrapped hot dog, seam side up and spaced well apart, on the prepared baking sheet.

5 Bake until the dough is golden brown, 10–13 minutes. Remove from the oven, let cool slightly, and serve warm.

JOSÉ'S "SWEDISH" MEATBALLS

These meatballs are half savory, half amazing!

INGREDIENTS

1 thick slice bread, crust removed

½ cup whole milk

½ lb ground beef

½ lb ground pork

1 onion, grated

3 tablespoons finely chopped flat-leaf parsley

¼ teaspoon garlic powder

2 teaspoons salt

1 teaspoon freshly ground pepper

2 tablespoons extra-virgin olive oil

Makes about 20 meatballs

1 Tear the bread into a few pieces and let soak in a small bowl with the milk. In a large bowl, combine the ground beef, ground pork, onion, parsley, garlic powder, salt, and pepper.

2 Mash up the bread and milk mixture with a fork, then pour it into the meat mixture. Using your hands, gently mix the ingredients to combine them evenly; avoid overmixing, which can make the meatballs tough. Scoop out small portions of the mixture and roll them between your palms to form 2-inch-thick balls; place the meatballs on a tray.

3 Line a plate with paper towels. Heat a large frying pan over high heat and add the oil. Working in batches, add the meatballs to the pan with enough space between them that they're not touching. Brown the outside of the meatballs, moving them with a wooden spoon to brown all sides. Once browned, transfer to the paper towel–lined plate to drain, and repeat until all meatballs are browned.

4 Place all the meatballs back into the pan, decrease the heat to low, and cook until firm, about 5 minutes. Serve at once.

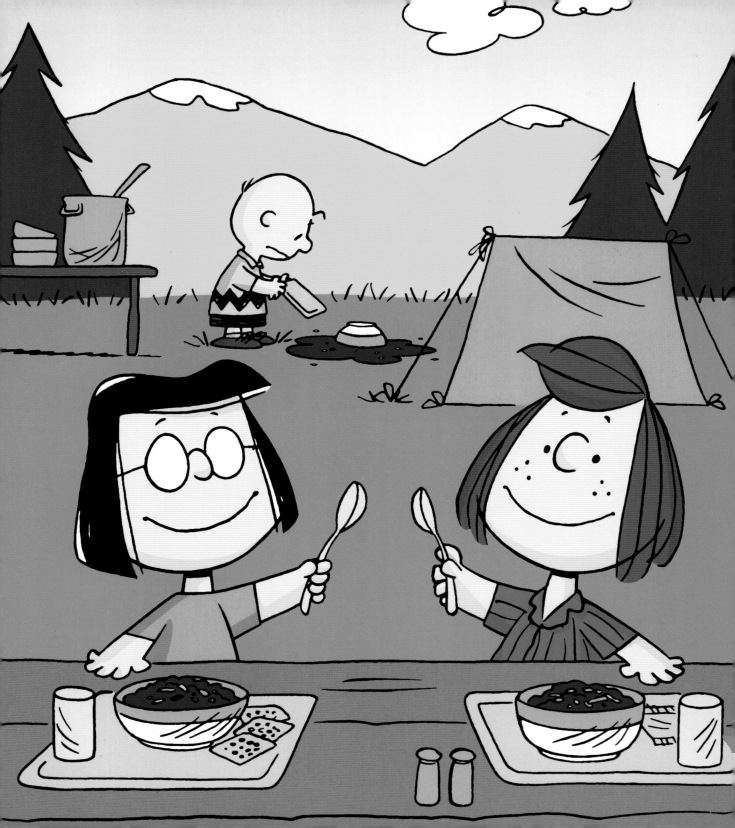

CAMP KAMP CHILI CHOW

A hearty bowl of camp chow is perfect after a challenging hike!

INGREDIENTS

1 tablespoon extra-virgin olive oil

½ cup chopped yellow onion

1 lb ground beef or turkey

2 cloves garlic, minced

1–2 tablespoons chili powder

1 teaspoon ground cumin

½ teaspoon dried oregano

2 cups low-sodium chicken broth

1 can (14 oz size) crushed tomatoes

1 can (15 oz size) kidney, black, or pinto beans, drained and rinsed

2 tablespoons tomato paste

Salt and freshly ground pepper

½ cup shredded Cheddar cheese, for serving

Makes 4 servings

1 In a large, heavy pot, warm the oil over medium heat. Add the onion and cook, stirring often, until translucent, about 5 minutes. Add the ground beef and garlic and cook, using a wooden spoon to break up the meat into small pieces, until the beef is browned, 5–7 minutes.

2 Add the chili powder, cumin, and oregano. Stir to mix well. Stir in the chicken broth, tomatoes and their juices, beans, and tomato paste and bring to a simmer. Reduce the heat to medium-low and cook until slightly thickened, 20–25 minutes. Season to taste with salt and pepper.

3 Spoon the chili into bowls, sprinkle a little cheese over the top of each, and serve at once.

SLOPPY JOE COOL

Ready to try a new recipe? Don't panic—this fun and delicious dish is so easy that it can be made by any ordinary Joe.

INGREDIENTS

1 tablespoon extra-virgin olive oil

1¼ lb ground beef or ground turkey

2 tablespoons firmly packed golden brown sugar

2 tablespoons minced onion

1 teaspoon paprika

1 teaspoon chili powder

½ teaspoon garlic powder

1 can (15 oz) tomato sauce

2 tablespoons tomato paste

2 tablespoons Worcestershire sauce

2 teaspoons red wine vinegar

Salt and freshly ground pepper

4 hamburger buns

Makes 4 servings

1 In a large frying pan over medium-high heat, add the oil and the ground beef and cook, using a wooden spoon to break it up into small pieces, until evenly cooked, 8–10 minutes. Reduce the heat to medium-low and add the brown sugar, onion, paprika, chili powder, and garlic powder. Cook, stirring, until blended, about 2 minutes.

2 Add the tomato sauce, tomato paste, Worcestershire sauce, and vinegar. Stir until well mixed. Bring to a boil over high heat. Immediately reduce the heat to medium-low and cook, stirring often to blend the flavors, about 5 minutes longer. Season to taste with salt and pepper.

3 Place a bun bottom, cut side up, on each of 4 plates. Spoon an equal amount of the meat mixture over the bun bottoms, then place the bun tops on top. Serve hot.

FRIEDA'S NATURALLY CURLY PESTO PASTA

This pasta dish is so good that it'll make your friends' hair curl! Add more garlic or more cheese to get the flavor just the way you want.

INGREDIENTS

¼ cup pine nuts

¼ cup walnuts

1 clove garlic

2 cups loosely packed fresh basil leaves

½ cup extra-virgin olive oil

½ cup grated Parmesan cheese

Salt

1 lb gemelli or fusilli pasta

Makes 4 servings

1 Bring a large pot of water to a boil. Meanwhile, make the pesto. In a blender or a food processor, coarsely chop the nuts and garlic together. Add the basil and oil and process until the mixture forms a coarse paste. Add the cheese and process briefly, just to incorporate it. The pesto should be fairly smooth but still have some texture. Season with salt to taste.

2 Generously salt the boiling water, add the pasta, and cook until the pasta is al dente, 10–12 minutes or as directed on the package. Drain the pasta, reserving about ½ cup of the pasta water. Put the pasta in a large, shallow bowl. Add a large dollop of the pesto (don't add it all at once, as you may not need it all). Add a few tablespoons of the reserved pasta water to loosen the sauce. Toss well. The pesto should be creamy and coat the pasta well, with little excess. Add more pesto as needed and toss again. Serve at once.

3 To store leftover pesto, transfer to a bowl, smooth the surface, cover with a thin layer of olive oil, cover with plastic wrap or a lid, and refrigerate; it will keep for 2–3 days.

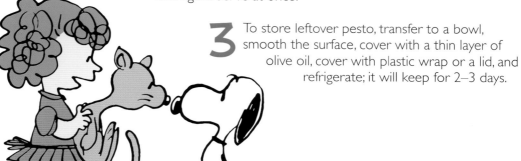

HI, MISTER BROWN... MY NAME IS CORMAC...I'M YOUR SWIMMING BUDDY..

I ADMIT I DON'T KNOW MUCH ABOUT SWIMMING...

IS YOUR NOSE SUPPOSED TO GO ABOVE THE WATER OR BELOW THE WATER?

CORMAC AND CHEESE

Just because you're small doesn't mean you can't make a big splash at the dinner table with this simple-yet-delicious pasta dish!

INGREDIENTS

2 tablespoons butter

2 tablespoons all-purpose flour

1½ cups whole milk

½ teaspoon ground nutmeg

½ teaspoon freshly ground pepper

½ teaspoon salt

2 cups shredded Cheddar cheese

2 tablespoons grated Parmesan cheese

½ lb elbow macaroni

Makes 4 servings

1 In a saucepan over low heat, melt the butter. Add the flour to the melted butter and, using a whisk, stir together until the mixture is smooth and bubbling but not browned, about 1 minute.

2 Raise the heat to medium. While stirring constantly with a wooden spoon, slowly pour the milk into the saucepan. Continue to stir and cook until the mixture is smooth, thickened, and gently bubbling, 6–8 minutes. Remove from the heat.

3 Stir in the nutmeg, pepper, and salt. Add the cheeses and stir until the cheeses have melted and the sauce is smooth. Cover the saucepan with the lid to keep warm and set aside.

4 Bring a large pot of water to a boil.

5 Generously salt the boiling water. Add the pasta and cook, stirring occasionally, until the pasta is al dente, 7–8 minutes or as directed on the package. Drain the macaroni.

6 Add the macaroni to the saucepan with the cheese sauce. Using a wooden spoon, stir the macaroni until it is well coated with the cheese sauce. Spoon the macaroni and cheese into bowls and serve at once.

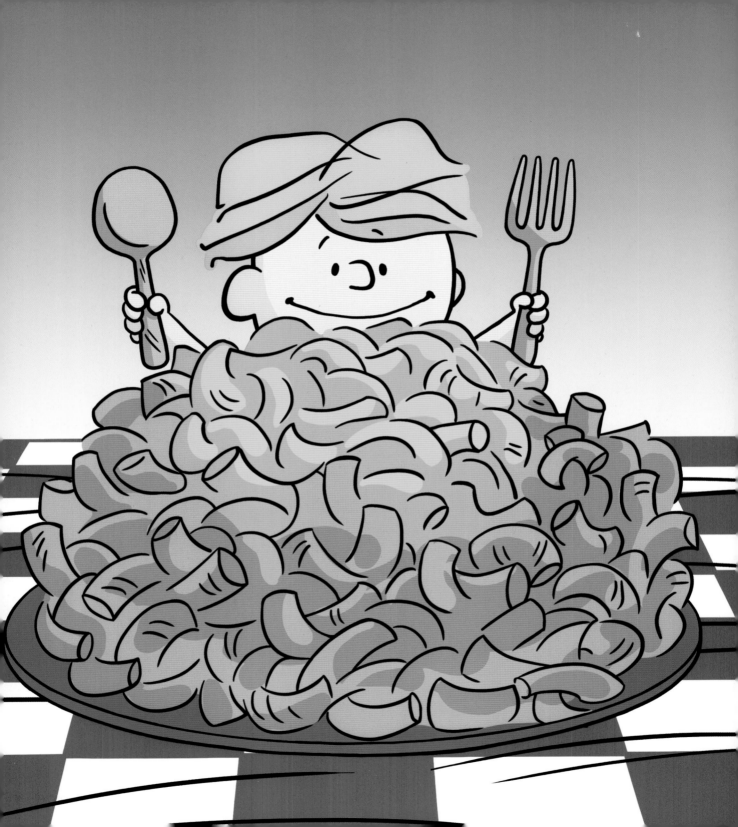

SNOOPY'S WORLD-FAMOUS PIZZA

Every day can be a treat with this special pizza recipe. For a little variety, add slices of pepperoni, salami, or your favorite toppings just before baking.

INGREDIENTS

1½ teaspoons active dry yeast

1¼ cups warm water

1 teaspoon sugar

3½ cups all-purpose flour, plus more for dusting

2 teaspoons salt, plus more for seasoning

2 tablespoons extra-virgin olive oil, plus more for drizzling

½ cup semolina flour, for dusting

1 cup store-bought tomato sauce

1 lb fresh mozzarella cheese, thinly sliced

¼ cup grated Parmesan cheese

Makes 4 pizzas

1 In a small bowl, sprinkle the yeast over ½ cup of the water, allow to bloom for a few minutes, then whisk until smooth. Whisk in the sugar, then whisk in ½ cup of the flour. Cover with plastic wrap and let stand in a warm spot until the mixture bubbles, about 15 minutes.

2 In the bowl of a stand mixer, stir together 2½ cups of the flour and the salt. Add the yeast mixture, the remaining ¾ cup water, and the oil. Fit the mixer with the dough hook and knead on medium speed, adding as much of the remaining flour as needed to reduce wetness, until the dough is elastic, pliable, and moist but not sticky, about 10 minutes.

3 Shape the dough into a ball, then divide it into 4 equal pieces. Roll each piece into a ball, place the balls on a lightly floured plate, cover with plastic wrap, and let rest for 15 minutes.

4 Position a rack in the lower third of the oven and preheat to 450°F. Lightly dust a large rimless cookie sheet with the semolina flour.

5 Pull apart the dough balls, and place 1 ball on a lightly floured work surface. Roll out into a round about ¼ inch thick. Prick the dough all over with a fork and transfer it to the prepared sheet.

CONTINUED . . .

6 Spread about ¼ cup of the sauce over the dough almost to the edge. Top with one-fourth each of the cheeses. Drizzle with oil and sprinkle with salt.

7 Bake until the crust is golden and the cheese is bubbling and starting to caramelize, about 10 minutes. Remove from the oven and slide the pizza onto a cutting board. Let cool for 5 minutes, then cut into wedges. Repeat with the remaining dough and toppings.

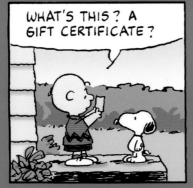
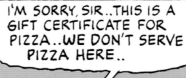
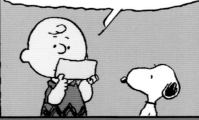

CHARLIE BROWN'S NOT-TOO-SPICY ENCHILADAS

You can use red or green enchilada sauce for this recipe, just be sure to read the label so your dish has just the right amount of heat!

INGREDIENTS

4 tablespoons canola oil

1 can (16 oz) enchilada sauce

1 cup chicken broth

Salt

12 corn tortillas

2 cups shredded cooked chicken

2 cups shredded Monterey jack cheese

½ cup sour cream

Makes 4 servings

1 Preheat the oven to 325°F. In a frying pan over medium heat, warm 1 tablespoon of the oil. Pour in the enchilada sauce and cook, stirring, until thickened, about 2 minutes. Add the chicken broth and cook, stirring frequently, until thick, about 5 minutes. Taste and adjust the seasoning with salt. Remove from the heat. Spoon a thin layer of the enchilada sauce onto the bottom of a 9-by-13-inch baking dish. Set aside.

2 Line a plate with paper towels. In another frying pan over medium heat, warm the remaining 3 tablespoons of oil until hot. Using tongs, quickly drag the tortillas one at a time through the oil to soften them on both sides, then place on the paper towel–lined plate to drain. Pat the tortillas dry with paper towels.

3 In a bowl, mix together the shredded chicken and cheese. Working with one tortilla at a time, spread a spoonful of the chicken-cheese mixture near the edge of the tortilla, roll it up, and place it seam side down in the prepared baking dish. Repeat with the remaining tortillas and chicken-cheese mixture, arranging the rolled tortillas side by side in the dish. Spoon the remaining sauce over the tortillas. Bake the enchiladas until they are heated through and the cheese is melted, about 15 minutes. To serve, top the enchiladas with sour cream and serve at once.

DESSERTS

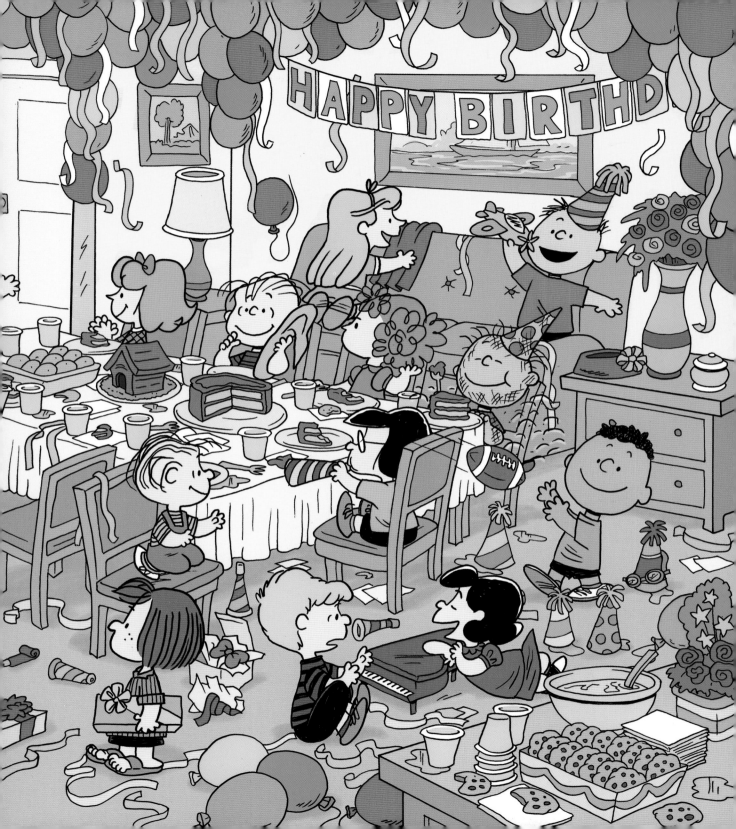

AND THEN, LINUS, I GOT SO NERVOUS TRYING TO TELL HER MY NAME, I SAID IT WAS "BROWNIE CHARLES"...

HA HA HA HA!! CHARLIE BROWN, YOU ARE REALLY SOMETHING!

© 1990 United Feature Syndicate, Inc.

7-28

NOW SHE CALLS ME "BROWNIE CHARLES" ALL THE TIME... BUT YOU KNOW WHAT?

I KIND OF LIKE IT..

CHARLIE BROWNIES

These brownies are so distractingly good that you may mistakenly call them Brownie Charlies!

INGREDIENTS

½ cup unsalted butter, cut into 4 pieces, plus more for greasing

3 oz unsweetened chocolate, finely chopped

1 cup sugar

¼ teaspoon salt

2 large eggs

1 teaspoon vanilla extract

¾ cup cake flour, sifted

¾ cup bittersweet chocolate chips

Makes 9 large brownies

1 Preheat the oven to 350°F. Lightly grease an 8-inch square baking dish.

2 In a small saucepan over low heat, combine the butter and unsweetened chocolate. Heat, stirring often, until melted, about 4 minutes. Remove from the heat and pour into a large bowl. Stir in the sugar and salt. Add the eggs and vanilla and stir until well blended. Sprinkle the sifted flour over the mixture and stir until just blended. Stir in the chips.

3 Pour the batter into the prepared dish and spread evenly. Bake the brownies until a toothpick inserted into the center comes out almost completely clean, about 30 minutes. Do not overbake. Transfer to a wire rack to cool completely before cutting into 2½-inch squares. Store the cut brownies in an airtight container at room temperature for up to 5 days.

WORMLESS CARAMEL APPLES

For a special treat without any tricks, make a batch of caramel apples that are guaranteed to thrill!

INGREDIENTS

2 bags (14 oz each) of caramels

8 popsicle or lollipop sticks

8 small apples

Makes 8 apples

1 Unwrap the caramels, place them in a small saucepan, and add ¼ cup water. Place the pan over medium heat and cook, stirring occasionally, until the caramels have melted and the mixture is smooth, 5–7 minutes. Keep warm over low heat.

2 Line a baking sheet with waxed paper. Insert a popsicle stick or lollipop stick into the stem end of each apple. Dip an apple into the caramel, coating it completely and letting the excess drip back into the pan, and place on the waxed paper. Repeat with the remaining apples, using a spoon to scoop caramel onto the sides of the apples if necessary. Let stand on the prepared baking sheet until the caramel has set, about 10 minutes.

3 Serve at once, or wrap individually in waxed paper and store in the refrigerator for up to 1 day. Bring to room temperature before serving.

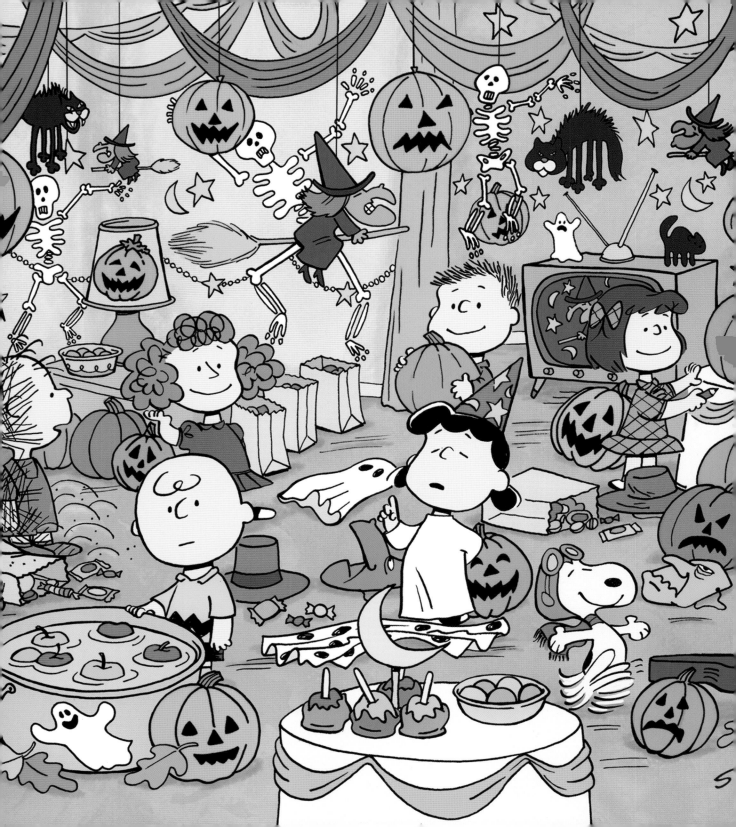

TAPIOCA'S PUDDING

This chocolate pudding is so good that it should be on T-shirts and lunch boxes!

INGREDIENTS

⅓ cup sugar

3 tablespoons cornstarch

1 cup (about 6 oz) semisweet chocolate chips

2 cups whole milk

1 teaspoon vanilla extract

Makes 4 servings

1 In a saucepan, combine the sugar and cornstarch. Stir in the chocolate chips, then slowly stir in the milk.

2 Place the saucepan over medium heat, stirring constantly, until the pudding is thick and smooth, about 6 minutes.

3 Remove the pan from the heat and stir in the vanilla. Set the pudding aside to cool, stirring often.

4 When the pudding has cooled, divide it among four small serving bowls and cover each bowl with plastic wrap. Refrigerate until chilled, about 1 hour. Remove the wrapping and serve at once.

TAPIOCA PUDDING

SIX
1/2 CUP
SERVINGS

NET WT
5.9 OZ (167g)

INSTANT MIX!

TAPIOCA PUDDING INSTANT MIX!

THE GREAT PUMPKIN PIE

The Great Pumpkin rises every year to give us this tasty Thanksgiving treat!

INGREDIENTS

FOR THE GINGERSNAP CRUST:

1½ cups crushed gingersnaps

3 tablespoons sugar

6 tablespoons unsalted butter, melted

½ teaspoon ground ginger

FOR THE FILLING:

3 large eggs

¾ cup firmly packed golden brown sugar

½ teaspoon *each* ground cinnamon and ground ginger

¼ teaspoon *each* ground cloves and ground nutmeg

½ teaspoon salt

1 can (14.5 oz) pumpkin purée (about 1⅔ cups)

1½ cups half-and-half or heavy cream

Whipped cream, for serving

Makes 8 servings

1 Preheat the oven to 350°F. To make the gingersnap crust, in a bowl, stir together the gingersnap crumbs, sugar, melted butter, and ginger until evenly moistened. Pat evenly into the bottom and up the side of a 9-inch pie pan. Bake just until set, about 5 minutes. Let cool completely on a rack.

2 To make the filling, in a large bowl, whisk the eggs until blended. Whisk in the brown sugar, cinnamon, ginger, cloves, nutmeg, and salt until well mixed. Stir in the pumpkin and half-and-half until blended. Pour into the crust.

3 Bake the pie until the filling is set, 45–50 minutes. Let cool completely on a rack. Cut into wedges, top each wedge with whipped cream, and serve.

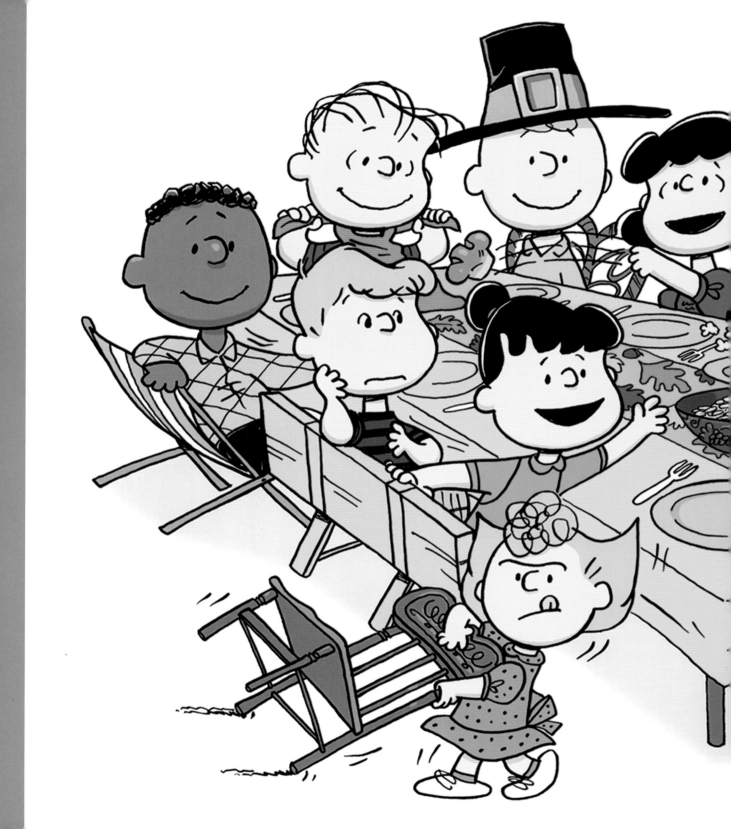

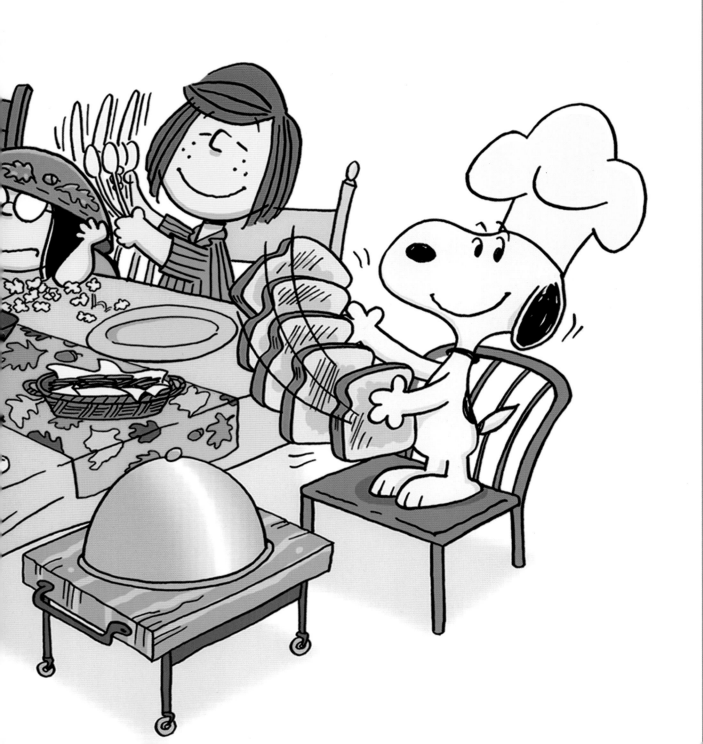

 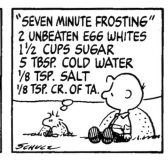

HAROLD ANGEL FOOD CAKE
WITH SEVEN-MINUTE FROSTING

There is nothing angelic about this devilishly delicious cake!

INGREDIENTS

FOR THE CAKE:

1 cup cake flour

1¼ cups superfine sugar

¼ teaspoon salt

1¼ cups egg whites (about 10 large eggs)

1½ teaspoons cream of tartar

1 teaspoon vanilla extract

FOR THE SEVEN-MINUTE FROSTING:

2 egg whites

5 tablespoons cold water

⅛ teaspoon cream of tartar

1½ cups sugar

⅛ teaspoon salt

1½ teaspoons vanilla extract

Makes 10 servings

1 Preheat the oven to 350°F.

2 To make the cake, in a bowl, sift together the flour, 1 cup of the superfine sugar, and the salt three times, and set aside. In a large bowl, using an electric mixer set on medium-low speed, beat the egg whites until foamy. Add the cream of tartar and vanilla, increase the speed to medium-high, and beat until the whites are soft and foamy. Gradually add the remaining superfine sugar and continue to beat just until medium-firm peaks form when the beaters are lifted. Do not overbeat.

3 Transfer the egg mixture to a very large bowl. Sift ½ cup of the flour mixture over it and, using a large rubber spatula, gently fold it into the egg whites using deep strokes. Add the remaining flour mixture in three equal batches, sifting and folding each time. Scoop the batter into an ungreased 10-inch tube pan and gently smooth the top. Bake until the cake is golden and springs back when touched, about 40 minutes. Remove from the oven and invert the pan onto its feet. Let cool completely.

I DON'T KNOW...I DIDN'T SEE THE REST OF THE PLAY..AS SOON AS SALLY SAID, "HOCKEY STICK," AND EVERYONE LAUGHED, I LEFT

SHE GETS EVERYTHING MIXED UP...SHE EVEN THOUGHT SOMEONE NAMED "HAROLD ANGEL" WAS GOING TO SING!

EXCUSE ME, SOMEBODY'S AT THE DOOR...

HI, IS SALLY HOME? MY NAME IS HAROLD ANGEL..

4 Meanwhile, make the frosting. Combine all the frosting ingredients except the vanilla in a heatproof bowl and beat with an electric mixer for 1 minute. Place the bowl over, but not touching, barely simmering water in a saucepan and beat constantly on high speed for 7 minutes. Beat in the vanilla. Remove from heat and let cool before using.

5 To remove the cake from the pan, gently run a long, thin-bladed knife around the inside of the pan and around the tube, pressing it firmly against the pan to prevent tearing the cake. Invert the pan and let the cake slide out. Frost the cake. Using a serrated knife, cut into slices to serve.

WOODSTOCK'S UPSIDE-DOWN CAKE

Cutting a pineapple can be tricky, so this recipe uses canned slices to keep it simple. You can also substitute slices of plum, peach, or your favorite fruit!

INGREDIENTS

Cooking spray

1 cup unsalted butter, at room temperature

¾ cup firmly packed brown sugar

1 can (20 oz) pineapple slices, drained

1¾ cups all-purpose flour

1 teaspoon baking powder

¼ teaspoon salt

¼ teaspoon ground nutmeg

1 cup granulated sugar

2 large eggs

2 teaspoons vanilla extract

½ cup whole milk

Makes 8 servings

1 Preheat the oven to 350°F. Lightly coat a 9-inch round cake pan with cooking spray.

2 In a small saucepan over medium heat, melt ¼ cup of the butter. Add the brown sugar and stir until small bubbles appear, about 2 minutes. Remove the sugar mixture from the heat and pour into the cake pan. Arrange the pineapple slices in a single layer in the pan and set aside.

3 In a large bowl, mix together the flour, baking powder, salt, and nutmeg, and set aside.

4 In the bowl of a stand mixer fitted with the paddle attachment, beat the remaining ¾ cup butter on medium-high speed until pale and fluffy. Gradually add the granulated sugar and beat for 2–3 minutes longer. Add the eggs, one at a time, beating after each addition. Beat in the vanilla. With the mixer on low speed, add the flour mixture in two additions, alternating with the milk, beating just until blended after each addition. Do not overmix.

5 Pour the batter over the pineapple slices in the pan, spreading it evenly. Bake until the top of the cake is lightly golden and the center springs back when lightly touched, 35–45 minutes. Let the cake cool in the pan on a wire rack for 5–10 minutes, then turn out onto a platter and scrape the remaining juices over the top of the cake. Let cool slightly and serve warm.

VIOLET'S DELUXE MUD PIE

A mud pie is just a mud pie, except when it's made from this deluxe recipe!

INGREDIENTS

FOR THE COOKIE-CRUMB CRUST:

1¼ cups chocolate-chip cookie crumbs

5 tablespoons unsalted butter, melted

3 tablespoons granulated sugar

FOR THE FILLING:

1 cup semisweet chocolate chips

4 tablespoons unsalted butter

¼ cup heavy cream

2 tablespoons light corn syrup

1 cup confectioners' sugar, sifted

1 teaspoon vanilla extract

1 qt premium coffee ice cream, softened

Makes 6–8 servings

1 Preheat the oven to 350°F.

2 To make the cookie-crumb crust, in a large bowl, combine the cookie crumbs, melted butter, and granulated sugar and stir until the crumbs are well moistened. Pat the mixture firmly and evenly into the bottom and all the way up the sides of a 9-inch pie pan or dish. Bake until the crust is firm, about 5 minutes. For a firmer, crunchier crust, bake for an additional 5 minutes.

3 To make the filling, in a microwave-safe bowl, combine the chocolate chips, butter, cream, and corn syrup. Microwave on high for 30 seconds. Stir, then microwave for 30 seconds longer or until melted. Remove from the microwave and stir until smooth.

4 Add the confectioners' sugar and vanilla to the chocolate mixture and mix well. Reserve ½ cup of the chocolate mixture for the top of the pie. Spread the remaining mixture evenly over the cookie crust in the pan. Refrigerate until well chilled, about 1 hour.

5 In a large bowl, using an electric mixer on medium speed, beat the ice cream until it is spreadable but not runny. Immediately mound it into the pie shell and spread evenly over the chocolate. Freeze until the ice cream is firm, at least 2 hours or up to overnight.

6 In a microwave for 30-second intervals, reheat the reserved chocolate mixture until it is spreadable but not hot. Drizzle it over the ice cream. Return the pie to the freezer until it is completely firm before serving, 3–4 hours. To slice, run a knife under hot water, then dry it off. If frozen overnight, the pie may need to sit out for a few minutes before it is soft enough to slice easily.

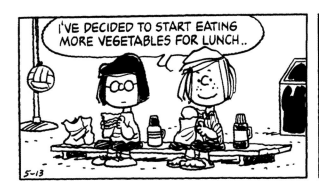
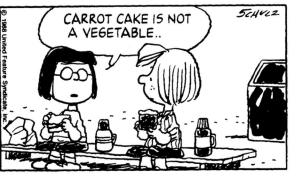

CARROTS–ARE–VEGETABLES CAKE

Marcie knows best, so have a healthy dinner before your carrot cake dessert!

INGREDIENTS

FOR THE CAKE:

2 cups all-purpose flour

2 teaspoons baking soda

2 teaspoons baking powder

2 teaspoons ground cinnamon

½ teaspoon salt

½ teaspoon ground allspice

4 large eggs

¾ cup vegetable oil

¾ cup granulated sugar

1 cup firmly packed golden
 brown sugar

½ cup buttermilk

3 cups peeled, shredded carrots

FOR THE FROSTING:

1 lb cream cheese

6 tablespoons unsalted butter,
 at room temperature

1¼ cups confectioners' sugar

1½ teaspoons vanilla extract

Makes 8 servings

1 Preheat the oven to 350°F. Butter and flour two 9-inch round cake pans.

2 To make the cake, in a bowl, sift together the flour, baking soda, baking powder, cinnamon, salt, and allspice, and set aside. In a large bowl, whisk together the eggs, oil, granulated and brown sugars, and buttermilk until blended.

3 Stir the flour mixture into the egg mixture until just combined. Fold in the carrots. Divide the batter evenly between the prepared pans.

4 Bake until a toothpick inserted into the centers comes out clean, about 40 minutes. Transfer the pans to racks and let cool in the pans for 15 minutes. Invert the cakes onto the racks and let cool completely.

5 To make the frosting, in a large bowl, using an electric mixer set on medium-high speed, beat the cream cheese and butter until smooth. Reduce the speed to low, add the confectioners' sugar, and beat again until smooth. Beat in the vanilla until well blended.

6 Place one cake layer on a plate. Spread 1¼ cups of the frosting over the top. Place the second cake layer on top. Spread the remaining frosting over the top and sides of the cake. Serve at once, or cover with plastic wrap and refrigerate for up to 2 days. Bring to room temperature before serving.

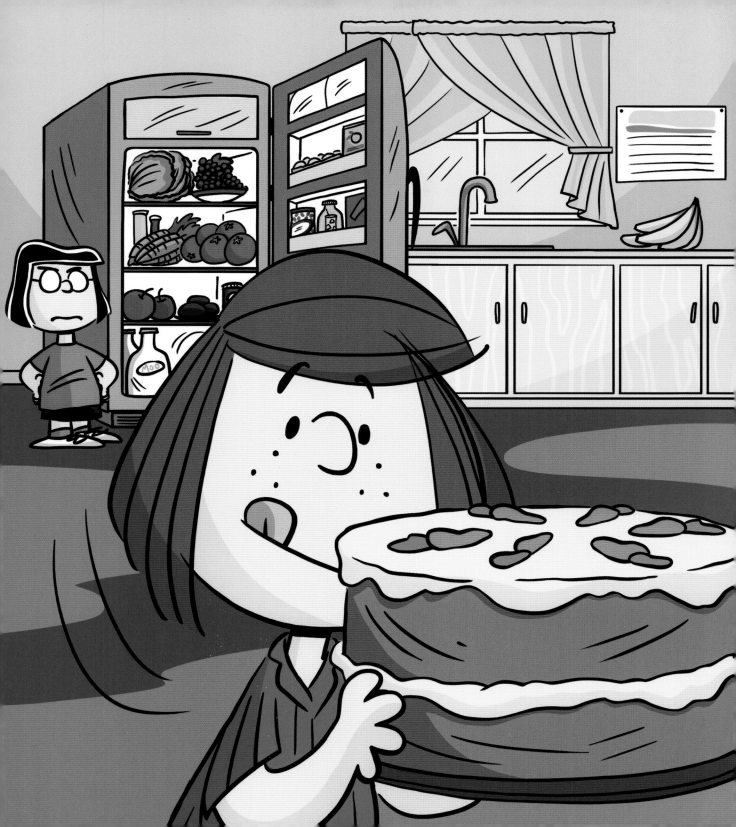

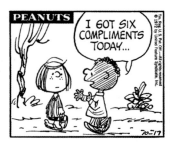
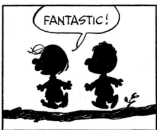
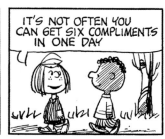
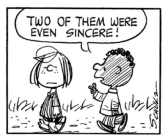

Panel 1: I GOT SIX COMPLIMENTS TODAY...

Panel 2: FANTASTIC!

Panel 3: IT'S NOT OFTEN YOU CAN GET SIX COMPLIMENTS IN ONE DAY

Panel 4: TWO OF THEM WERE EVEN SINCERE!

FRANKLIN'S FROZEN FRUIT CRUSH

This refreshing dessert is the perfect treat after a day at the beach, hockey practice, or studying for a test (or all three!).

INGREDIENTS

1 cup sugar

12 plums (about 4 lbs), halved and pitted, plus plum slices for garnish

Makes 6 servings

1 In a small saucepan over medium heat, combine the sugar with 1 cup water and bring to a boil. Reduce the heat to medium-low and simmer until the sugar has completely dissolved, about 10 minutes. Set aside to cool.

2 Pour the cooled sugar mixture into a blender. Add the plums and process until smooth.

3 Pour the mixture into a 9-by-13-inch glass baking dish, cover with plastic wrap, and place in the freezer for about 1 hour. Remove from the freezer, uncover, and, using a fork, rake the mixture into flakes. Return to the freezer and repeat this process every 30 minutes until the mixture looks like shaved ice, about 3 hours total.

4 Scoop the granita into glasses or bowls, garnish with plum slices, and serve at once.

SLURP, SLOP, SLURP VANILLA ICE CREAM

Resist the urge to be a piggy with this classic ice-cream dish—there's enough to share with all your friends!

INGREDIENTS

2 cups cold heavy cream

1 cup cold whole milk

¾ cup sugar, preferably superfine

1 tablespoon vanilla extract

Makes about 1 quart

1 In a large bowl, whisk together the cream and milk. Add the sugar and whisk until completely dissolved, 3–4 minutes. Stir in the vanilla. Cover and refrigerate for 3 hours or up to 24 hours.

2 Pour the cream mixture into an ice-cream maker and freeze according to the manufacturer's directions. Transfer to a freezer-safe container and freeze until firm before serving, at least 3 hours or up to 3 days.

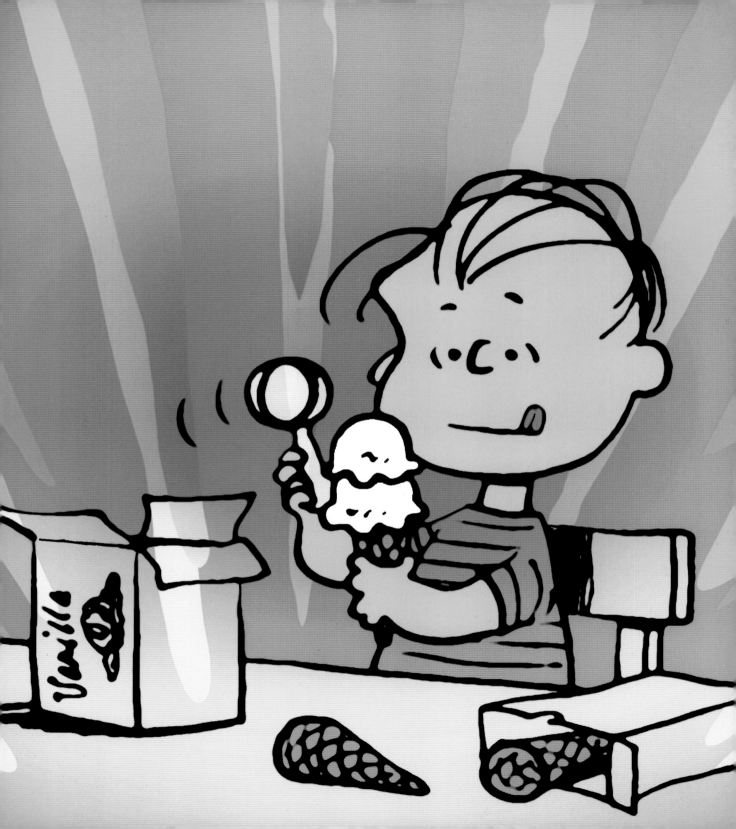

PEGGY JEAN'S CHOCOLATE-DIPPED SHORTBREAD HEARTS

Homemade cookies, dipped in love, are the perfect valentine!

INGREDIENTS

2¼ cups all-purpose flour, plus more for dusting

1 teaspoon baking powder

½ teaspoon salt

½ cup unsalted butter, at room temperature

¾ cup sugar

1 large egg

2 tablespoons whole milk

1 teaspoon vanilla extract

1½ cups semisweet chocolate chips

1½ tablespoons vegetable shortening

Makes about 3 dozen cookies

1 In a bowl, combine the flour, baking powder, and salt and whisk until well blended, and set aside. In a large bowl, using an electric mixer on medium-high speed, beat the butter and sugar until light and fluffy. Beat in the egg, milk, and vanilla until smooth. Add the flour mixture to the butter mixture and mix on low speed or stir with a wooden spoon until smooth. Turn the dough out onto a lightly floured work surface and form into a ball. Divide the dough in half and form each piece into a thick disk, smoothing the edges. Place in a lock-top plastic bag and refrigerate for at least 2 hours or for up to 2 days.

2 Preheat to 350°F. Line two baking sheets with parchment paper. Remove 1 disk of dough from the refrigerator and let stand on a lightly floured work surface for about 5 minutes. Pound the disk a few times with a rolling pin to soften it. Roll out the dough to a thickness of about ⅛ inch, turning it over and dusting it and the work surface lightly with flour as needed to prevent the dough from sticking.

3 Using a heart-shaped cookie cutter, cut out cookies. Then, using a metal spatula, transfer the cookies to the baking sheets, spacing them about 1 inch apart. Form the dough scraps into a ball, reroll, and cut out more cookies until all the dough is used. (You may need to refrigerate the scraps until they're firm enough to roll out.) Bake the cookies, one sheet at a time, until firm but uncolored on the top and lightly browned on the bottom, about 10 minutes. Let the cookies cool briefly on the pan on wire racks before transferring them to the racks to cool completely. Repeat with the second disk of dough.

4 To melt the chocolate, in a microwave-safe bowl, combine the chocolate chips and shortening. Microwave on high for 30 seconds. Stir, then microwave for 30 seconds longer or until melted. Remove from the microwave and stir until smooth.

5 Line the cooled baking sheets with fresh parchment paper. One at a time, dip half of each cookie into the melted chocolate, then place on the prepared baking sheet. When all the cookies are dipped, place the baking sheet in the refrigerator just until the chocolate is set, about 5 minutes. Store the cookies in an airtight container at room temperature for up to 5 days.

SWEET BABBOOS

Give your loved ones a unique sweet treat to show you care—personalized with your thumbprint!

INGREDIENTS

½ cup unsalted butter, at room temperature

3 tablespoons sugar

¾ teaspoon vanilla extract

¼ teaspoon salt

1 cup all-purpose flour

3 tablespoons jelly or preserves of your choice

Makes 16 cookies

1 Preheat the oven to 400°F. Line a baking sheet with parchment paper.

2 In a large bowl, combine the butter, sugar, vanilla, and salt. Using an electric mixer set on medium-high speed, beat until the mixture is light and fluffy. Add the flour to the butter mixture and mix on low speed to form a smooth dough.

3 Roll rounded teaspoonfuls of the dough between your palms into balls. Place the balls on the prepared baking sheet, spacing them about 1 inch apart. With your thumb, make an indentation in the center of each ball. Spoon a small amount of jelly into each indentation.

4 Place the baking sheet in the oven and bake until the cookies are just beginning to brown, about 10 minutes.

5 Let the cookies cool briefly on the pan on a wire rack before transferring them to the rack to cool completely. Store the cookies in an airtight container at room temperature for up to 5 days.

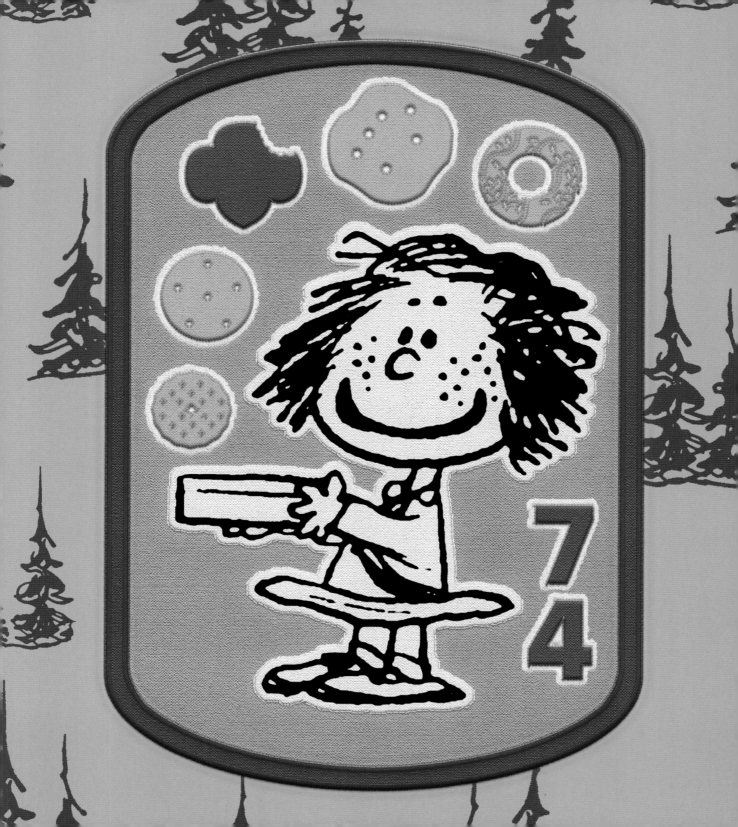

 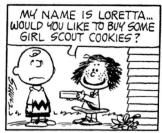

LORETTA'S CHOCOLATE CHIP "GIRL SCOUT" COOKIES

If your local scout troop isn't selling cookies, Loretta's chocolate chip delights are the next best thing for a yummy treat.

INGREDIENTS

1⅓ cups all-purpose flour

½ teaspoon baking powder

½ teaspoon baking soda

½ teaspoon salt

½ cup unsalted butter, at room temperature

½ cup granulated sugar

½ cup firmly packed light brown sugar

1 large egg

1 teaspoon vanilla extract

1 cup semisweet chocolate chips

Makes about 4 dozen cookies

1 Position two racks in the middle of the oven and preheat to 350°F. Line two baking sheets with parchment paper.

2 In a bowl, sift the flour, baking powder, baking soda, and salt, and set aside. In a large bowl, using an electric mixer on medium-high speed, cream the butter until fluffy and pale yellow. Add the granulated and brown sugars and continue beating until the mixture is no longer gritty when rubbed between your finger and thumb. Add the egg and vanilla and beat on low speed until blended, occasionally stopping the mixer and scraping down the sides of the bowl with a rubber spatula as needed. Add the flour mixture to the butter mixture and mix on low speed or stir with a wooden spoon just until blended. Add the chocolate chips, mixing or stirring just until blended.

3 With dampened hands, shape the dough into 1-inch balls and place the balls on the baking sheets, spacing the cookies about 2 inches apart.

4 Bake the cookies until golden brown around the edges, about 12 minutes. Let the cookies cool briefly on the pans on wire racks before transferring them to the racks to cool completely. Store the cookies in an airtight container at room temperature for up to 5 days.

PEANUTS

MARCIE AND I ALMOST WON, THE POWDER PUFF DERBY, CHUCK

BUT YOU KNOW WHAT **HE** DID? HE TOOK BACK HIS AIRPLANE, AND WE COULDN'T FINISH THE RACE...

I PAID HIM A DOLLAR TO RENT HIS PLANE, AND I CAN'T EVEN GET MY DOLLAR BACK BECAUSE HE SPENT IT ALL ON COOKIES...

SCARF CITY!

PEPPERMINT PATTY CANDY CANE COOKIES

These cookie twists are a great reward for staying active even in winter!

INGREDIENTS

2 cups all-purpose flour, plus
more for dusting

¼ teaspoon baking powder

¾ cup unsalted butter, at
room temperature

¾ cup sugar

I large egg

I teaspoon vanilla extract

Red food coloring

Makes about 20 cookies

1 Position two racks in the middle of the oven and preheat to 375°F. Line two baking sheets with parchment paper.

2 In a bowl, combine the flour and baking powder with a wooden spoon, and set aside. In a large bowl, using an electric mixer on medium-high speed, beat the butter and sugar until the mixture is well combined. Add the egg and vanilla and beat until light and creamy. Decrease the speed to low, and gradually beat in the flour mixture until smooth.

3 Using your hands, gather the dough into a mass in the bowl and divide it in half. Transfer one half to a small bowl and cover with plastic wrap. Add a few drops of red food coloring to the remaining half in the large bowl. With the mixer on low speed, beat until the dough is evenly colored. Keep beating in the food coloring a few drops at a time, until the dough is the shade you desire. Cover the bowl with plastic wrap.

4 Using your fingers, lightly dust a flat work surface with flour. Roll I tea-spoonful of the red dough between your palms into a ball. Using your hands, roll the dough ball back and forth on the work surface to form a 6-inch-long rope. Repeat with the remaining red dough and the plain dough.

5 Place one red rope next to one plain rope, pinch the two ropes together on one end and gently twist the ropes around each other. Gently bend one end to form the hook of the cane, then pinch together the other ends to secure them. Transfer to a prepared baking sheet. Repeat with the remaining dough, spacing the cookies about I inch apart on the baking sheets.

6 Bake the cookies until golden brown around the edges, about 10–12 minutes. Let the cookies cool briefly on the pans on wire racks before transferring them to the racks to cool completely. Store the cookies in an airtight container at room temperature for up to 5 days.

SNOOPY'S CHRISTMAS COOKIES

These simple gingerbread cookies can be cut into festive holiday shapes and decorated with frosting, colorful crystal sugars, and sprinkles.

INGREDIENTS

1½ cups all-purpose flour, plus more for dusting

2 teaspoons baking powder

1 teaspoon ground cinnamon

½ teaspoon ground ginger

¼ teaspoon ground cloves

¼ teaspoon salt

¾ cup firmly packed golden brown sugar

½ cup unsalted butter, at room temperature

1½ tablespoons whole milk

Makes about 30 cookies

1 Position two oven racks in the middle of the oven and preheat to 375°F. Line two baking sheets with parchment paper.

2 In a bowl, combine the flour, baking powder, cinnamon, ginger, cloves, and salt with a wooden spoon until combined, and set aside.

3 In a large bowl, using an electric mixer on medium-high speed, beat the brown sugar and butter until the mixture is well blended. Add the milk and beat until blended. Decrease the speed to low and gradually add the flour mixture until the dough becomes too stiff for the beaters to work.

4 Add any remaining flour mixture to the bowl. Knead the mixture to mix in any flour with a pressing and pushing motion. Continue kneading until the dough is smooth and well blended. Divide the dough in half and roll each half into a ball.

CONTINUED . . .

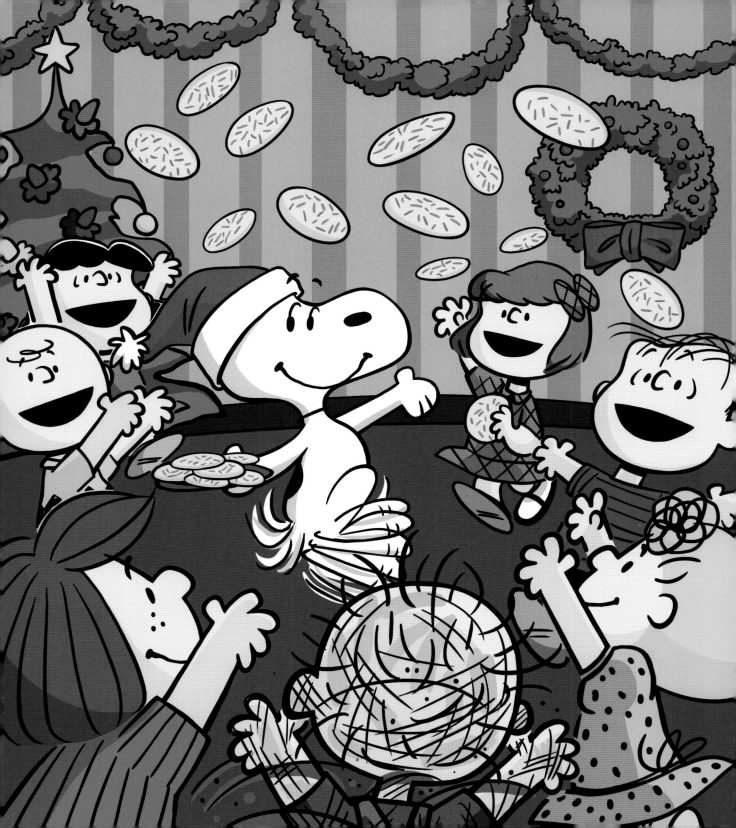

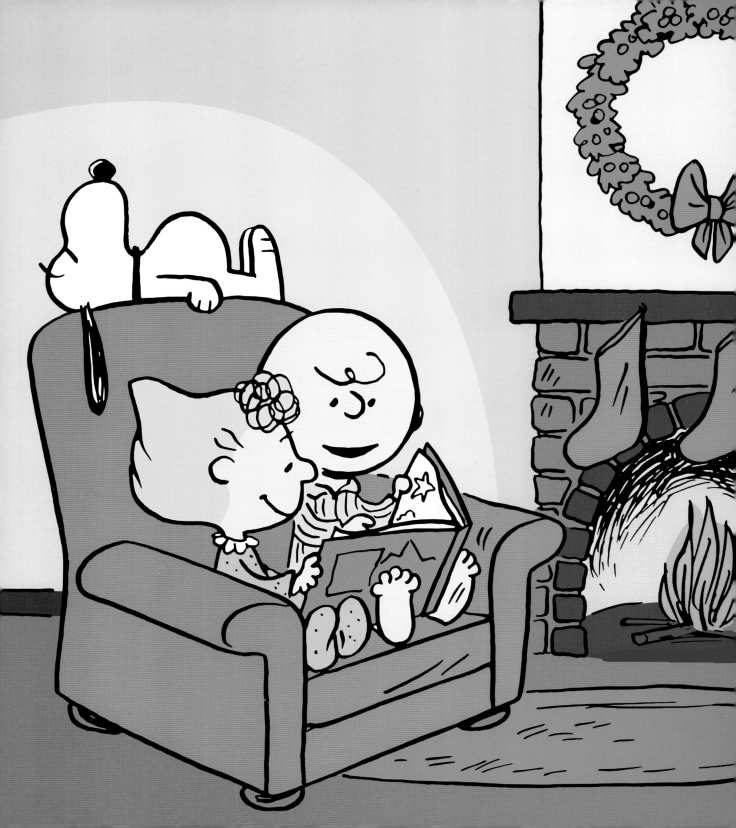

5 Using your fingers, lightly dust a flat work surface and a rolling pin with flour. Place 1 ball of dough on the floured work surface and roll out the dough into a large rectangle about $\frac{1}{8}$–$\frac{1}{4}$ inch thick.

6 Using cookie cutters in desired shapes, cut out cookies. Then, using a metal spatula, transfer the cookies to one of the prepared baking sheets, spacing them slightly apart. Gather the scraps of leftover dough into a ball and knead until smooth (if the dough becomes too crumbly to knead, add a few drops of milk). Repeat with the second ball of dough, transferring the shapes to the second baking sheet.

7 Bake the cookies until very lightly golden around the edges, about 10–12 minutes, rotating the pans halfway through. Let the cookies cool briefly on the pans on wire racks before transferring them to the racks to cool completely.

8 Decorate as desired. Store the cookies in an airtight container at room temperature for up to 5 days.

INDEX

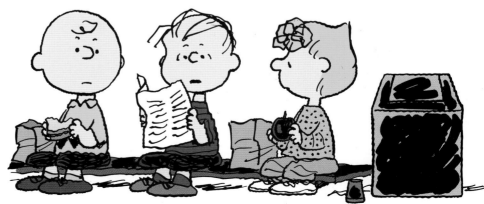

CREDITS

CHARLES M. SCHULZ is the artist for all strips, panels, and excerpts appearing in this book, unless otherwise cited.

PEANUTS WORLDWIDE: Endpapers; pages 1, 2–3, 4–5, 6, 7, 44, 59, 60, 75, 118, 121, 128

CHARLES M. SCHULZ CREATIVE ASSOCIATES: 8–9, 12–13, 40–41, 56–57, 62–63, 65, 79, 81, 86–87, 90, 91, 96–97,

CAMERON + CO: pages 17: art by Schulz, design by Iain Morris; 20: art by Schulz, design by Emily Studer; 28: art by Schulz, design by Emily Studer;

43: art by Schulz, design by Iain Morris; 70: art by Schulz, design by Amy Wheless; 93: art by Schulz, design by Regina Shklovsky; 109: art by Schulz, design by Iain Morris; 114: art by Schulz, design by Rob Dolgaard; 117: art by Schulz, design by Emily Studer

ROBERT POPE: Front cover; pages 18, 22, 27, 32, 37, 50, 68, 72, 81, 84

VICKI SCOTT: Back cover; spine (top); pages 47, 48, 53, 54, 79, 101, 102, 105, 110, 119

IMAGE DESIGN COURTESY OF KAMIO JAPAN INC.: pp 14–15

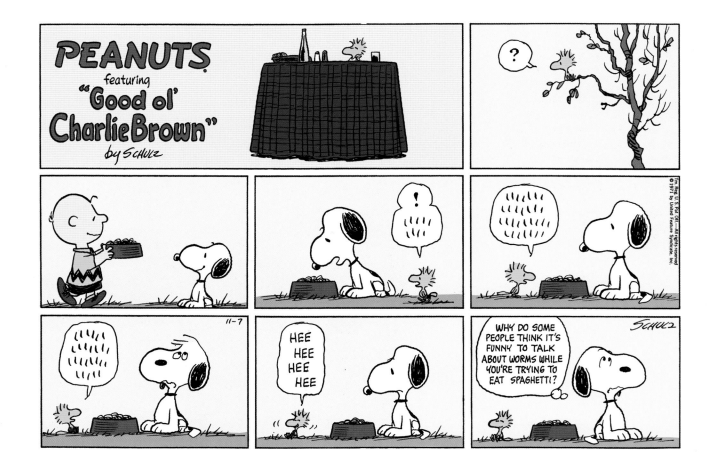

weldon**owen**

Weldon Owen International
1150 Brickyard Cove Road
Richmond, CA 94801
www.weldonowen.com

Introduction, page 10, by Lynn Downey, from the Charles M. Schulz Museum exhibit *Mud Pies and Jelly Beans: The Flavor of Peanuts*, used with permission

Library of Congress Cataloging-in-Publication data is available.

ISBN: 978-1-68188-423-3
Printed in China
10 9 8 7 6 5 4
2022 2023

President & Publisher Roger Shaw
SVP, Sales & Marketing Amy Kaneko
Associate Publisher Mariah Bear
Acquisitions Editor Kevin Toyama
Creative Director Kelly Booth
Art Director Allister Fein
Production Designer Howie Severson
Production Director Michelle Duggan
Production Manager Sam Bissell
Imaging Manager Don Hill

Weldon Owen would like to thank Amy Marr, Lisa Atwood, and Lesley Bruynesteyn for their help in bringing these tasty dishes to the kitchen table.

Produced in conjunction with Cameron + Company
Publisher Chris Gruener
Creative Director Iain Morris
Designer Melissa Nelson Greenberg
Design Assistants Regina Shklovsky, Amy Wheless, Emily Struder
Managing Editor Jan Hughes
Proofreaders Mason Harper and Elizabeth Hayt

Cameron + Company would first and foremost like to thank Charles M. Schulz for bringing *Peanuts* into the world. We would also like to thank Peanuts Worldwide LLC and Charles M. Schulz Creative Associates for keeping his legacy alive and for their help in making this book possible—special thanks to Senior Editor Alexis E. Fajardo for his tireless efforts on this project. A resounding thank-you to Roger Shaw, Mariah Bear, and Kevin Toyama of Weldon Owen, for believing in this project and making this book possible.